# SAMARAS

# SAMARAS

The Photographs of Lucas Samaras

Essay by Ben Lifson

An Aperture Book

*The Publisher and Lucas Samaras give special thanks to Eelco Wolf for his support and guidance on this project.*

Copyright © 1987 Aperture Foundation, Inc.
Photographs © 1987 by Lucas Samaras; text © 1987 by Ben Litson.
All rights reserved under International and Pan-American Copyright Conventions.
The term "AutoPolaroid," selected by the artist to identify his first published Polaroid photograph in 1971,
was used without the consent of Polaroid Corporation, owner of the registered trademark "Polaroid."
At the request of Polaroid Corporation, the artist has refrained from using the term in identifying his
subsequent Polaroid photographic work.
Published by Aperture Foundation Inc.
20 East 23 Street, New York, N.Y. 10010
Distributed to the general book trade in the United States by Farrar, Straus and Giroux, Inc.
Composition by David E. Seham Associates Inc., Metuchen, New Jersey.
Printed and bound in Hong Kong by Everbest Printing Co. Ltd.

Library of Congress Catalog Number: 87-071325
ISBN: 0-89381-241-2
Design: Manfred Heiting
Editor: Larry Frascella
Managing Editor: Lisa Rosset
Design Associate: Laura Quick
Editorial Assistants: Diana Mignatti and Sloane Lederer
Production: Stevan Baron, Barbara Sadick, Birgit Mettmann
The bibliography and lists of exhibitions and collections
were prepared with the assistance of the Pace Gallery,
Robin Jaffee, Kirstin Chotzinoff, and Jennifer Atkinson.

# Introduction

Lucas Samaras lives alone in a small apartment on Manhattan's Upper West Side, far from the downtown artists' quarters of SoHo and TriBeCa. His is a milieu of writers, musicians, psychotherapists, and old moneyed families. Once pocketed with slums, the West Side is now filling with young professionals and chic stores. Samaras's liking for small dwellings is an expression in life of his distance from the heroic scale of Abstract Expressionism. Away from the art world, he also safeguards his creative singularity. But the apartment is not a hermitage. There are many dinner parties and frequent guests —artists, critics, dealers, friends, visitors from Greece (where Samaras was born in 1936), and family from both sides of the Atlantic.

A half-light suffuses the apartment. High ceilings, dense bookshelves, dark parquet floors, and black furniture and screens absorb much of the light from small lamps and a crystal chandelier with tiny bulbs. Shades and curtains are always drawn. Only the small, square kitchen, with its fluorescent lamps, is bright.

There are not enough corners, shelves, cabinets, or walls; Samaras's things encrust every surface. Wherever you sit, fragile or precariously stacked objects are near at hand. Wet canvases on the floor make walking about difficult; unbaked clay sculptures of embracing, wrestling grotesques at the edges of shelves make you shrink into yourself lest you knock one off. Glittering, nacreous, exotic, the objects seem all the nearer because they magnetize you. You are engulfed by Samaras's things.

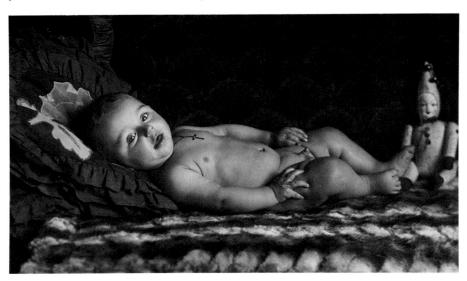

Samaras's photographs document the light, possessions, and changes of this apartment and the man who lives there, and create the brilliance, spectacle, and metamorphoses of a mythological demesne and the protean character who possesses and is possessed by it.

Photographs began to appear in many of Samaras's works as early as 1963. They were slightly different prints of the same image, a professionally done head shot of Samaras—the type of portrait actors refer to as a ''glossy'' and use as the carte-de-visite of their profession. Samaras's glossies, like many things in his assembled art, were leftovers, specifically from the few months of 1962 and '63 when he tried and failed to become an actor.[1] Similar prints still turn up in Samaras's art; you will see their images in some of the Still-Lifes, rolled up inside tall glass cylinders. Their first appearances in his works, on the faces of boxes, or by themselves, stuck with pins, were Samaras's first artistic gestures toward photography.

Six years later, he bought a camera and started to photograph himself. Up to this moment his approach to photography was ambivalent. Previously, each use of a photograph in an artwork—pierced by pins, hidden by glass splinters, multiplied by prisms—was an assault on the photographic image itself. But during the same period, Samaras would occasionally offer himself as subject matter to photographers. To his mind, the issue was always the same, and in part traditional: photography's long-standing ambiguous status as art, or transcription, or fiction, or fact, or all. He was also uncomfortable being photographed by others, and viewed any direct image of himself as a falsification, mutilation, and loss of the self.

It is now clear that Samaras could resolve these issues only when he stopped using photography as a subsidiary element in his art, embraced the medium's aesthetics, mastered its craft, and plotted his aesthetic course according to photography's terms. Also Samaras, whose assemblages had often included tokens of himself (hair, fingernails, molds of his body parts), could not become a photographer until he accepted the photographic image— the illusion of a direct and literal description—of himself as a motif. This meant reviving and adapting for the camera dramaturgical skills he had learned in happenings and as a student of the famed acting teacher Stella Adler. He had to become an embodier of the

self, whom he, as artist, would agree to depict. Similarly, he had to become a photographer whose skill, gaze, and memory he could trust, an artist in whose works he would agree to appear, as he had earlier agreed to be cast in plaster by George Segal and to act in the happenings of Alan Kaprow, Claes Oldenburg, and Robert Whitman.[2]

Samaras split himself into model, artist, actor, director, audience, and critic, variously and ambiguously subjective and objective. To each of these roles he brought a skilled artist's hand and an eye deeply informed by the historical traditions and motifs of art and by the vernacular and popular traditions of photography. He became a rare figure in American art, not an artist who occasionally uses photography for tactical reasons, or merely quotes, collages, or conceptualizes it, or uses it to document works that would have no other permanent record, but an artist who made photography central to his aesthetic campaign.

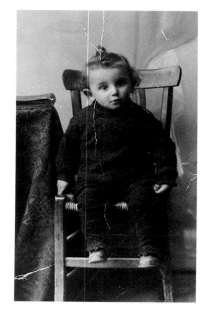

Looking back on his remarkable achievement of eighteen years, one sees that it is obsessed with and energized by a great dilemma: the quest for and picturing of an integrated self, discovered in a process that cancels the hero's aspects even as it enlarges them. The themes are built up out of logically irreconcilable terms: simultaneous recognition of child and adult; of isolated individual and social being; of mundane earthling, celestial hero, and damned soul; of the observer and the observed. These thematic contradictions are accompanied by aesthetic ones: photography as a presentational and narrative art, the photograph as documentary and imaginative image.

Photography for Samaras began in his childhood, during World War II, in the Macedonian city of Kastoria. His first memories of the medium are of being photographed. Samaras's father had been in New York when the war began and, except for a 1947 visit to Greece, stayed in America.

Until the family was reunited in New Jersey in 1948, "pictures of the son," says Samaras, "had to be sent to the father."[3] Snapshots of the child with his mother, aunts, and cousins were sent; Samaras also remembers his mother's taking him often to a photographer's studio where he posed shyly in front of a painted backdrop. These early, almost sacramental appearances before the camera are fused in Samaras's mind with other, equally official visits to the studio when his mother went to be photographed for her wartime identity papers.

This was before art came into Samaras's life, and long before he considered the photograph as an art object. The photographic surface, for example, was not sacrosanct. Identity-card pictures were stamped and written on; family snapshots were crudely retouched to remove whole figures; and pictures of his father in Samaras's wallet got stained, cracked, and torn. There were icons in his mother's house; some were paintings, others were photographic reproductions, but it didn't occur to the child that any of them could *not* be paintings, so distant was photography from art. Yet some photographs had the mystery, fascination, and power of icons; Samaras remembers picture postcards an aunt received from America. One showed a man with three legs, another Siamese twins.

When Samaras and his mother rejoined his father in West New York, across the Hudson River from Manhattan, they brought many photographs, which were soon put into albums. One of Samaras's great pleasures during his first years in America was to sit with these albums and rearrange their contents. As he shuffled and reshuffled the snapshots, the album became a continually revised history of his family and city in Greece, and Samaras discovered photography's capacity for fiction.

His fictions were often governed by beauty rather than history or emotion. "Sometimes," he says, "it turned out that the aunt who got the most play in the albums was not the aunt I liked the best, but the one who had the best pictures."[4]

"When I was growing up I used to go the Museum of Modern Art and look at whatever they had there, Van Gogh, Seurat, Malevich. . . . But they also had photographs. At the same time . . . I wanted to be an artist. . . You know, the child—or the young adult, rather—wants to be like somebody else who's successful. So I wanted to do images equal to [those of] any of those photographers. I took a course in photography in high school, but I didn't do anything significant. Either I didn't know how, or whatever I aimed my camera at was wrong."

Photographers have often linked the flourishing of their art to the moment a specific camera came into their lives; for Samaras the camera was the Polaroid 360, which he bought in 1969.

"I came home and I took my clothes off and it was wonderful, I never had such a wonderful experience with a camera or photography before. It was like finding some fantastic lover, and you were unworthy, but you were glad that this ethereal creature was paying you a visit, and it was without tragedy. . . ."

With photography, Samaras's art of the self changed as profoundly and physically as a life changes with a marriage or a birth. The human face and figure were brought out from under the layerings of his boxes, rescued from the soft stylizations of his pastels, and restored to his art as if in the flesh. John Szarkowski has remarked, "The trained artist could draw a head or a hand from a dozen perspectives. The photographer discovered that the gestures of a hand were infinitely various. . . ."[5] Con-

sider the portraits with which this book begins, their panoply of smiles, grimaces, stances, tapering and spreading chests; the photographer has discovered as many ways to draw a shoulder, jaw, or hairdo as the model has invented ways to paint a face or wear a wig. The portraits are also fecund with flirtations, seductions, pouts, and wounds. The assemblage artist's diversity of materials is transformed—by photography—into a diversity of emotions.[6] A small black-and-white photograph of Samaras embracing his double in his kitchen—an impossible snapshot of domestic affection—has the tenderness and awkwardness of everyday life, whereas his earlier art had only the density and ambiguous threat of it. The embracing figures rise out of the cluttered table in the narrow but clear space beyond, and pantomime Samaras welcoming Samaras back from art, home to himself.

"Also, the picture looked good, not a stupendous artwork but a solid picture, an honest day's work. It's not what I thought photography was going to be, the grand, rich images at the Museum of Modern Art or fancy photographs like you saw in the photography magazines, but poor images. They were plain. I started putting them in albums, and started composing them so that they became like different chapters."

To work with the Polaroid camera, to pose in the kitchen, to work in the plain style, to mount the photographs in albums, is to work in reference to an amateur tradition and a familial audience. The sentimental double exposure of Samaras in Samar-

as's arms has the snapshot's sense of occasion, commemoration, and privacy, even if the depth and solemnity of its embrace are greater. Many of the frankly sexual images can also be understood as solemn reworkings of the high-spirited naughtiness that punctuates many family albums. But we see neither family nor friends in Samaras's early photographs, and assume his first audience to be himself.

*"When you live alone you become the audience, the other, to your own life. And falling in love with yourself is stupendous. You have the power, you can turn it any way you want, make the drama go this way or that. Whereas if it's another person, you have to deal with uncontrollables, irrationalities."*

Samaras calls the early pictures AutoPolaroids; when he published them in 1971 he called the book *Samaras Album*. A series of self-commemorations, its moments are not the ceremonies and outings in which we trace our progress and our children's. Samaras records his taking possession of himself in the photographic moment of the pose. Absorbing the roles of lover, child, and spouse, and appropriating the love and memory of the parent, he is free to create himself according to his own inner defiance and desire.

The child of the Greek photographs who stood nervously against the photographer's backdrop, who nestled into the protection of women's bodies, who leaped from his mother's arms in antic virtuosity, posturing for an adult world, is here a man and claims and approves his manhood: drag queen, Jewboy, potentate, pimp, he tries on everything the immigrant father would condemn in the immigrant son, rejects the immigrant's dream of success, and naturalizes himself through American vulgarity. Wooing himself, he becomes the object of all his sexualities and pleases only himself.

Samaras depicts himself as the outcast, a cultural stereotype of the sixties embodied in the heroes of beat fiction and poet-

ry, Marlon Brando's motorcyclist, James Dean's rebel, and adolescents everywhere in life. By 1969, when Samaras started to photograph himself, social stereotypes had also been discovered as a theme in American photography. Robert Frank's *The Americans* is, among other things, a catalogue of men and women who dress and behave according to the costumery and scenarios of marginal but also mythical American figures—the drifter, the solitary cowboy in urban streets, the visionary black preacher, the flamboyant transvestite. The strength of Frank's black nursemaid holding a white baby in Charleston, South Carolina stems in part from the astonishment of seeing a literary stereotype of southern racial behavior so perfectly portrayed by the stoic woman and the little girl, who is at once white and smooth as a Dresden doll and imperious as a southern sheriff. The titles of Diane Arbus's portraits underline her subjects' existence as social exemplars—"Transvestite at a drag ball, N.Y.C. 1970," "Puerto Rican woman with a beauty mark, N.Y.C. 1965," "Mexican dwarf in his hotel room in N.Y.C. 1970," "A Jewish couple dancing, N.Y.C. 1963." Tod Papageorge has likened the people of Garry Winogrand's street photographs to the stock characters of "a sort of urban minstrel show . . . |with| interlocutors, end men, shimmering women pulled in from the wings. . . ."[7] Winogrand's 1977 *Public Relations* began in the late sixties as a study of the way politicians, sports heroes, and antiwar demonstrators shape their public behavior for the mass media and act according to "the cues and techniques of public performance."[8]

While other photographers let themselves be influenced by this school and hunted for similar types in the streets, Samaras understood that cultural types could inhabit an American landscape of the mind, and as figures in consciousness and fantasy could best be seen removed from the context of the streets, isolated in a studio, and enacted by a single, impressionable self. A little more than a decade later still younger American

postmodernist photographers were to come to the same under-standing, turn to the studio, become their own models, and pose as characters whose images of themselves were received entirely from movies, popular magazines, and television. Unlike those of these recent characters, the boundaries of Samaras's hero's ego are not so porous. Where postmodernist photographer-models become the types they imitate, Samaras reimagines and reembodies his outcast stereotypes as himself, entirely within his own psychological and physical dimensions.

*"It was my image, my body, worthy to be preserved. We have the example of Hollywood: some stars were pretty, some not, but most had a certain magnetism for the multitude. When I was growing up my body didn't have that magnetism, but I wanted that image."*

In his kitchen Samaras measures himself against the stereotype and asserts his singularity through the strategy of multiplication, enacting many types and overwhelming the rigidity and two-dimensionality of each by multiplying the type itself into a rich fund of extravagant posturings and flamboyant moods. He goes further and creates mutations, multiple assaults against the species, and pictures these self-mutilations as clowns.

As the character strains for heroic self-creation, the photographer yearns after a grand style. The portrait heads, even the grotesques, begin in self-conscious imitation of the great thirties' and forties' Hollywood glamour portraits.

*"My photographic excursion was to be the equivalent of a whole enterprise. It usually takes a number of people to build up an image. In Hollywood you need photographers, directors, publicity people, and then you have an image: Clark Gable, Spencer Tracy, George Arliss. . . . But here, out of no-where, one two three, I create this image."*

But imitation often falters just inside the frame, fades just before the light gives out, and we are back in the apartment with its rumpled beds and its dishes on the table; back in the amateur's flawed version of the professional's idiom. Because it is flawed, it is revealed as parody—that is, other than what the original intends. Samaras's hybrid style is a dialectic that subverts and cancels its own creations.

His apartment is not the exotic self-contained studio of its pretense but is subject, like ours, to ordinary mess and imper-fection. Yet in this defeat Samaras has prevailed. He annexes his studio to great portrait studios of nineteenth- and early twentieth-century photography—Nadar's, Brady's, Sander's—which present themselves as both in and removed from the world and are given to the pose as a theatrical act and as a distillation of hundreds of moments of self-presentation in everyday life.

The character too is off, doesn't conform to the masks Samaras only seems to put on—movie queen, movie tough guy, wolf man, pasha. He is too complex, and too eager to please—even the mutants plead for understanding—and Samaras always comes too close to the lens. Burlesque and satire give way to description, and the character poses as he is, a man who slicks his hair down, puts on wigs, and paints his face for the pleasure of being photographed that way. At the instant of exposure, stance and being are one because the conventional glamour the hero longs for is beyond the compass of his parody.

Naked, painted, adorned, and histrionic, the character Samaras creates from himself is a pure version of the hero of the photographic portrait, someone who sits to be stared at and, staring back, gives us a pose in which he asks us to recognize him as a singular version of ourselves.

As he joins this tradition we become the other, and sense that he appeals to us, paints his face so painstakingly and presents it so eagerly for us, and asks for our love. His need, like his invention, seems endless. He returns to the camera repeatedly to beseech, blandish, cajole, and cry. His mockery strikes us as an effort to disguise the vulnerability of his plea for recognition, the adult's defense hoisted up between the child's fear and the world's rejection. Samaras's parody of our common portrait types and idioms creates him in our image. But to a self-possessed hero this is lukewarm comfort, and Samaras takes another tack.

# AutoPolaroids

The AutoPolaroids refer to the closed space of theater; Samaras thinks of them in terms of happenings.

*"There's a tragic element to happenings. It was a nice body of work and it only lives in small corners of people's minds; there were no significant photographs of it. And then, most of the happeners left. They did not want their psyches, their young manhood, to be expressed that way; they wanted to do paintings. In those years, people would say, "Samaras, when are you going to do a happening?" When Polaroid came along, it was ideal. I could do a happening in my own time. There would be no accidents, no audience. And I would present it when it was finished."*

Samaras's AutoPolaroids strike us as untitled production stills, but they do not preserve moments from actual dramas or happenings. Instead they take moments from an invented theatrical life and transpose them to art as images that can be read as sketches for dramatic scenes. Samaras has understood photography's capacity to capture moments in life that might have given rise to art and whose images can reflect both art and life.

These pseudodramas propose that Samaras's young manhood and artistic psyche also be reembodied and preserved outside the vulgar terms of the B-movie. Emerging from a rumpled sheet piled high on his crouching back, as if hatching from an egg, he offers himself to Bosch. For the Mannerists he is naked, supine, and foreshortened. Against a fashion photographer's backdrop paper and a wall covered with dots and calligraphic markings, posing with a column, a bicycle, a chair, an umbrella, and his own works, surrounded by the assemblage artist's materials, he pictures himself against a shorthand history of art. It is an illustrated lecture and a spectacle; he is the lecturer, ringmaster, and eternal motif.

The painted dots and graffiti in this series of pictures are not actually on the wall of Samaras's apartment but on the photographic surface. Samaras started painting on his pictures to disguise out-of-focus, overexposed, and otherwise flawed passages (as his family in Kastoria had retouched photographs to eliminate unwanted characters). But the paint has become part of the photographic illusion, seems part of the surfaces depicted within the print itself. With these markings, Samaras enlarges his field of artistic reference: surrounded by dots and graffiti, he offers himself to the Post-Impressionists and Pop artists.

Samaras's apotheosis is only desired, his artistic heaven only a parody. The dots surrounding his body like a galaxy surrounding a constellation are neither stars nor the master's brushstrokes; a plastic cylinder is neither a classical pedestal for his classical stance nor transparent enough to let him seem to fly; and the chair he holds is not Van Gogh's. Photography, like the world, will not allow such transmutation. Samaras knows this.

Before we can say the emperor has no clothes, Samaras couches his spectacle in vulgarity, returns it to theatricality, and disarms us. Thus the figure is always his, and beautiful in its photographic specificity and mimetic virtuosity. Pose, body, cock, chair, dots, and photograph, as parodies of art, are beautiful; they seem taken from the collective unconscious of centuries of art and from a storehouse of the artist's own desires, and re-rendered in terms of the cultural present and the conflicts of Samaras's psychological singularity.

But the paint, theatricality, and blatant illusion are somber, for they disclose what would happen if the hero were literally absorbed by art. As the paint is drawn into the illusion, it eats into the artist's body; he is consumed by what beautifies him. He overwhelms, depletes, and disfigures himself with art. Like a man besotted with drink, he stops courting us, covers his eyes, forgets the world, shrieks, crouches like a fetus, and sleeps.

The fiction of Samaras's photography takes on its major theme, the parallel development of an art and a self.

A series of Grids (completed from 1970 to 1971) and a handful of cut and reassembled pictures followed the AutoPolaroids.

The Grids began with a return to the imagery of Samaras's pastels of 1965, which ended with a small group of pictures, each a study of one of Samaras's fingers. At that time Samaras asked a professional to photograph isolated parts of his body in relation to a "sunset or sunrise, up on the roof somewhere, some monumentalization of parts of my body. But [the photographer] brought up objections: if you focused on your finger, how could you possibly focus on the sunset, etc.," and the project was abandoned. In the Grids, Samaras takes it up again and solves its problem by isolating his subjects—body parts, objects, things in nature—from the body, the apartment, and the world.

The separate photographs of each work are arranged on a page in two or three rows, with three, four, or five photographs to a row—grids of six, nine, twelve, or fifteen images; some grids contain only black-and-white photographs, some color, and some both. Each photograph is physically isolated from the others by the imposition of a deep-cut overmat. Thus each pictured object—knife, tree, foot, and so on—even if it is pictured in several photographs, is isolated from all the others, as it is isolated, within the photograph, from its surroundings or the body. The effect is first that of a disintegration, a dissociation, an atomization of body, self, and world.

Samaras seems to structure the grids in narrative form, as earlier he had structured the family album to create stories of Kastoria and had arranged his Polaroid albums into chapters. But a line in a grid only proposes narrative connections. The grid as a whole frustrates the tentative beginnings, middles, and ends.

From frame to frame very little happens: a foot advances or retreats; a mug and a spoon change their relation to each other; fingers knead a stomach. No action is advanced, no character is developed, no points of view other than optical ones are introduced. The Grids imitate the impressions of sight on consciousness, the transfixing presences of objects, spaces, and body parts, the disappearances and reappearances of phenomena as they present themselves to the consciousness of the child who begins to take possession of his body and the world. But also, like the infant who cannot distinguish between the world and himself, Samaras is transfixed by morphological correspondences between his body and the things around him.

The AutoPolaroids' photographer seems to craft his pictures in collaboration with the hero's desires; each meets the other's needs, even through irony. The Grids begin to detach the artist from his character, and each set of images seems a sum of many intelligences and sensibilities. The eye that fixates on a fingernail, a blade of grass, or a corner of a room, unaware of the subject's surroundings, may be the child's, but the eye and hand that guide and place the pictures in their grids are literate and schooled in art. The artist's eye sees the inside of an elbow as a piece of biomorphic Surrealist sculpture, a foot on a bathroom floor as a monumental form on tiles that quote the diminishing Grids of Renaissance perspective studies. Mugs, saucers, forks, knives, razor blades, safety pins, and hanging scissors be-

come exercises in still life, and the Grids themselves a series of themes and variations.

The intelligence that directs this play is coolly subversive. As Samaras frustrates narrative and subtracts literary meaning from his depicted objects, he deprives his pictures of literal representation and undermines his subjects' substantiality. Objects and parts of the body approximate the conditions of abstract artistic form. In the past, photographers have made their photographs abstract by closing in on the subject or withdrawing to immense, often aerial distances from it, by flattening perspective, and by working in light that obscures and smoothes the recessions and projections of ordinary sight—picturing the object in a context created entirely by the picture, removed from life.[9] But Samaras always keeps a human—child's or adult's—distance from his subjects; his pictures are first of all descriptions of what something recognizable looked like from a specific vantage point. Still, the broken narrative and the grid create in us the feeling that elbow, weeds, and face are dissolving into insubstantial forms, and make us doubt photography's capacity to describe anything as itself. The Grids at once appeal to and isolate our sympathy, appreciation, and intelligence, and frustrate each faculty. In various ways, Samaras's later photographs will confuse our responses with the same intensity.

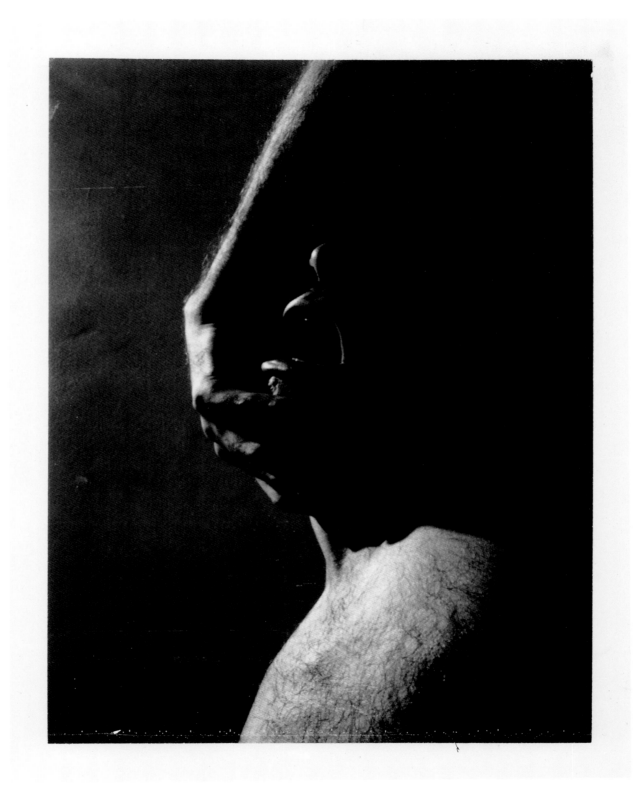

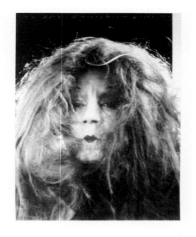 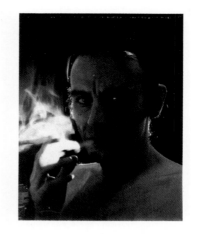 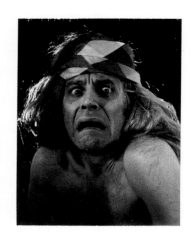

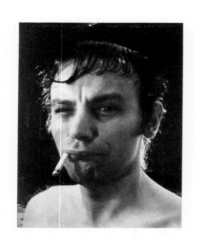 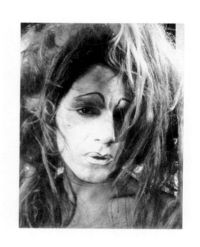 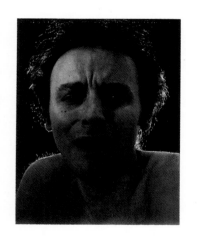

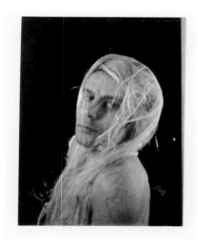 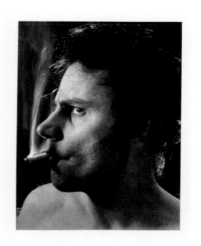 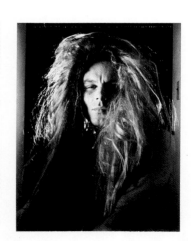

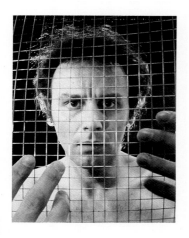 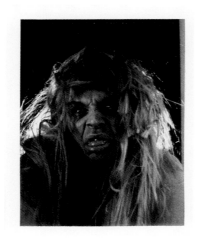 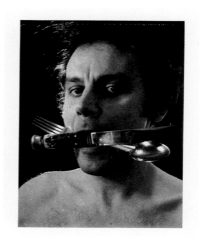

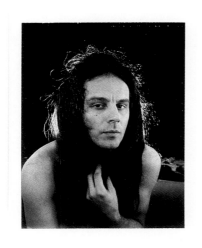 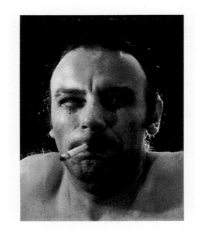 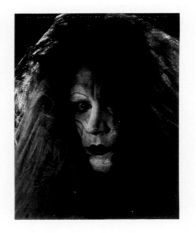

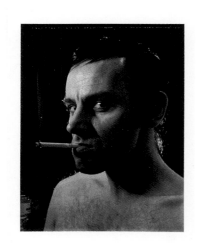 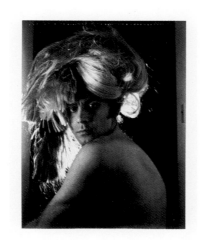 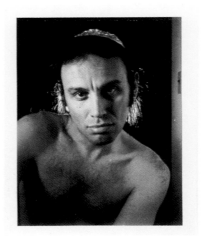

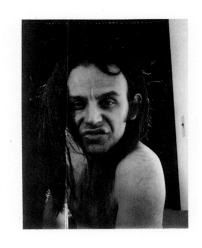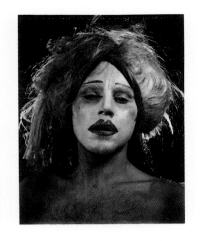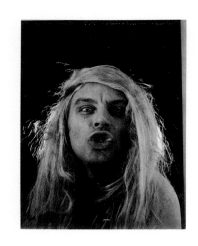
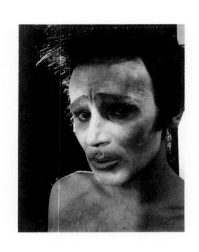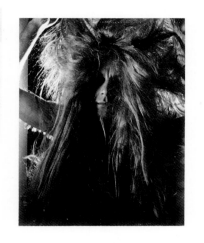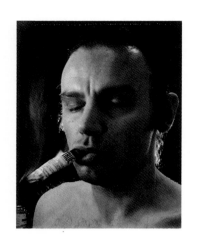
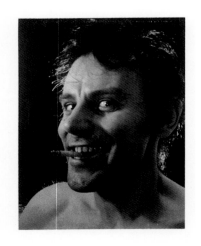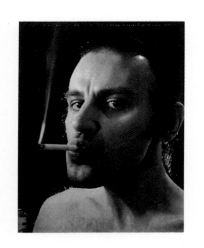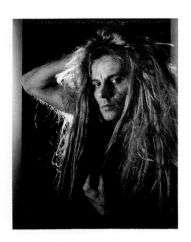

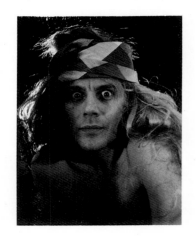 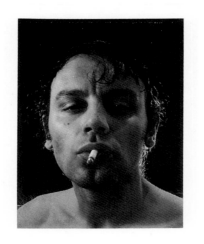 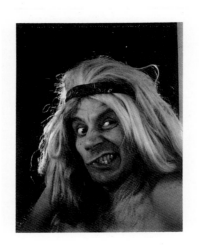

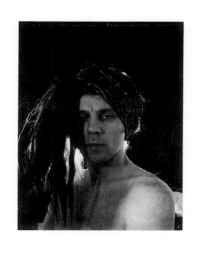 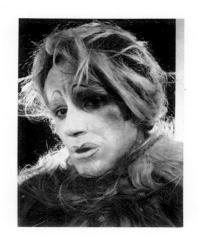 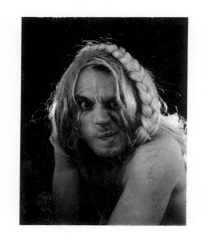

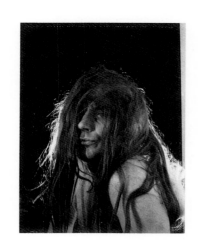 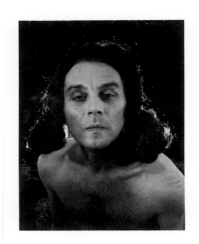 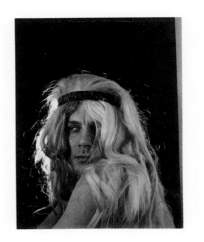

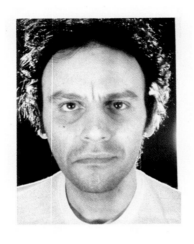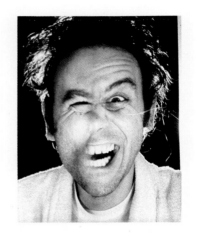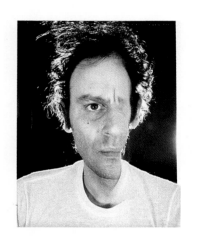
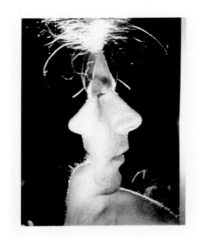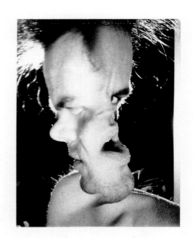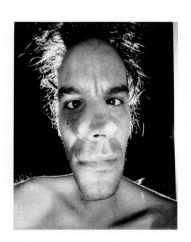

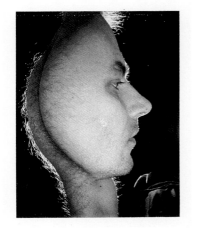 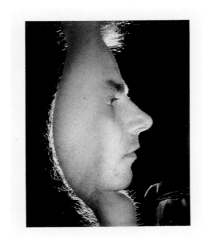 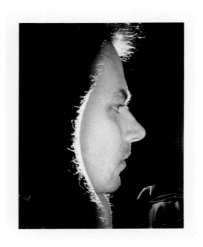

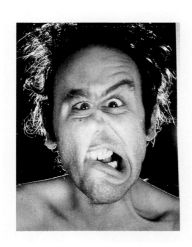 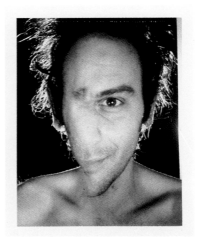 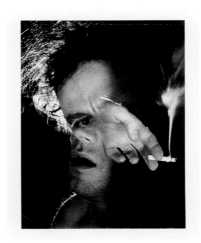

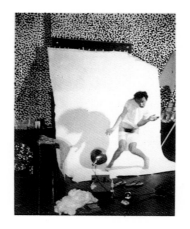
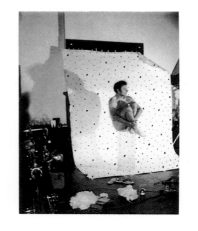
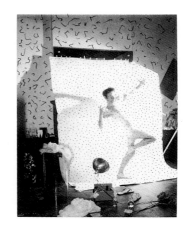
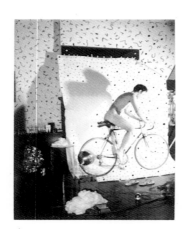

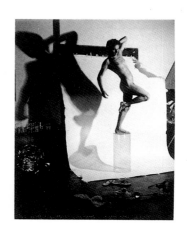
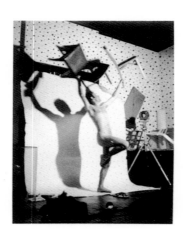
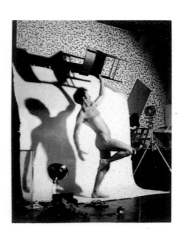
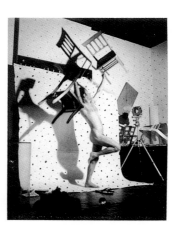

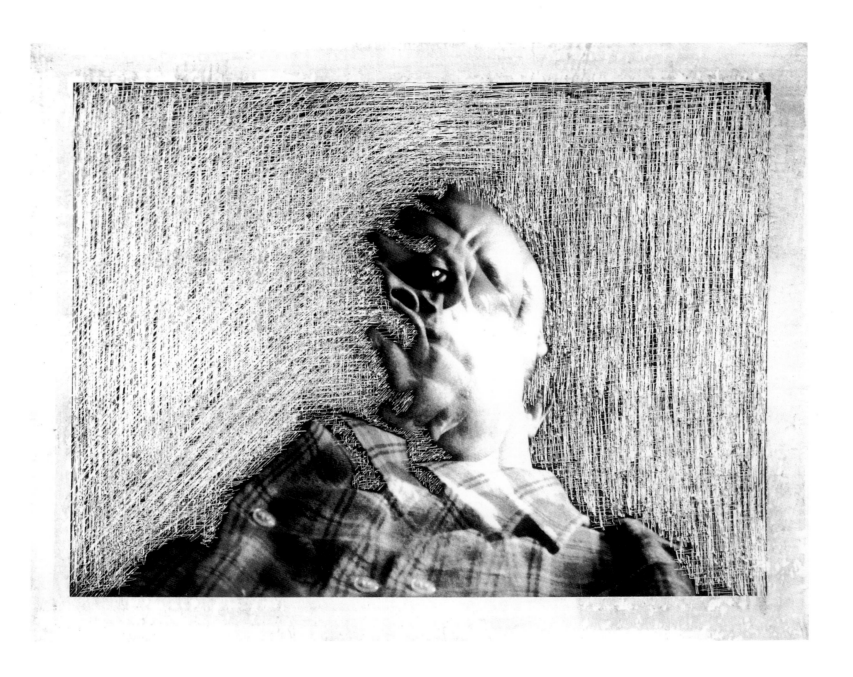

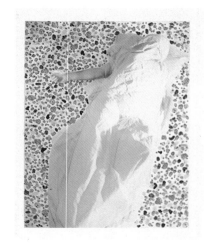

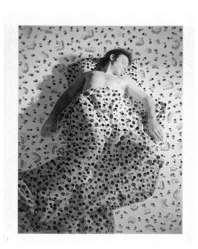

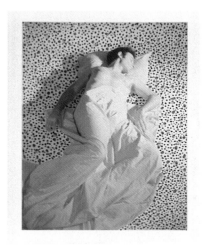

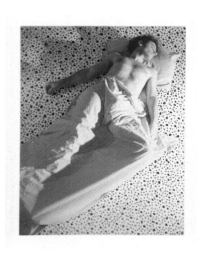

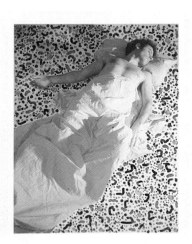

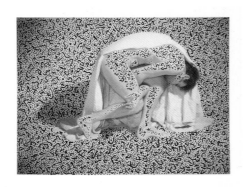
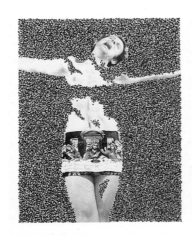
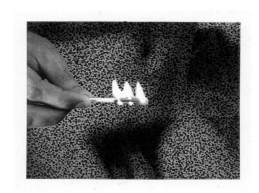

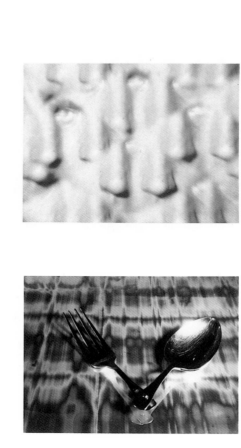

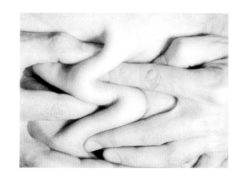

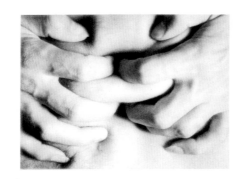

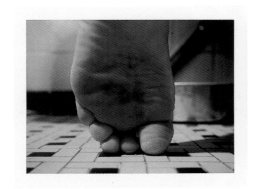

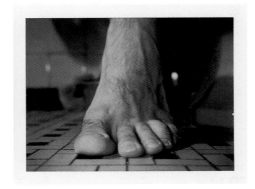

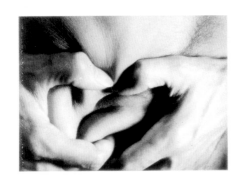

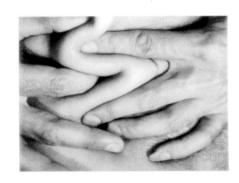

Splits

After the AutoPolaroids and Grids were exhibited, Samaras stopped photographing. But he was left with a large residue of duplicate and unsatisfactory photographs. These became material for a series of images he called Splits. Samaras cut leftover photographs along the diagonal and put halves from different pictures together to form new images, subjecting the photograph once more to the terms of assembled art. But by this time Samaras could also see photographs as pictures that combine the decorative intensity of painting with the credibility of photography. While within each triangle some surprises look planned, and some images—the skeletal, mournful, triply exposed saint's head—look worked for, along the diagonal edge everything looks accidental, seen and held in an instant.

The cut is to Splits what the frame is to dogmatically uncropped photographs, a constraint. Putting the pieces together, Samaras gave himself another photographic problem: chance recognition. To split the photograph was to return its halves to the world as fragments, materials, found objects, fragments of the world's diversity. Sitting at his table shuffling triangular pieces of photographs was a version of the photographer's daily walk on the lookout for coincidence. Samaras combined an image of a knife with an image of a pair of legs, and a new creature stepped into view.

In the Grids, whole pictures were seen as fragments and reintegrated according to the modernist tradition of the grid itself. With the Splits, Samaras reintegrates the fragments into pseudophotographs that recognize chance events as quotations and reminiscences of art: a knife with legs walks out of a romantic sky like a figure from Magritte. The photographer, writes John Szarkowski, "learned that the world itself is an artist of incomparable inventiveness, and that to recognize its best works and moments, to anticipate them, to clarify them and make them permanent, requires intelligence both acute and supple."[10] It is to that intelligence that Samaras's Splits refer. We can understand Samaras's reconstructed pictures as proposals for unmanipulated photographs of the world seen in and past a mirror, bringing fragments of reality into shocking coherence.

The fictional hero of the Splits is in pain: he is a haloed saint who lusts for men; a masochist who threatens his own body; an insatiable, almost bestial creature that longs to consume itself and the world. The mirror has cracked, the act of self-portraiture has become the prelude to self-analysis.

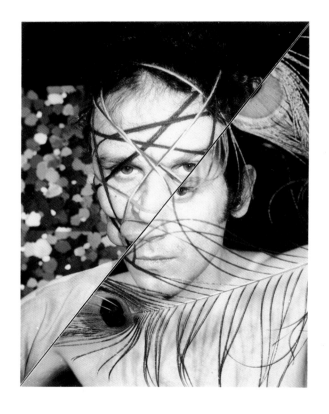 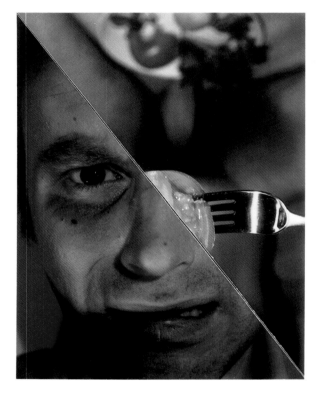 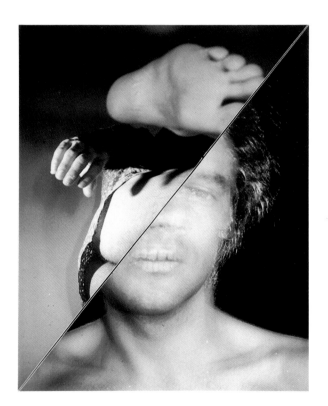

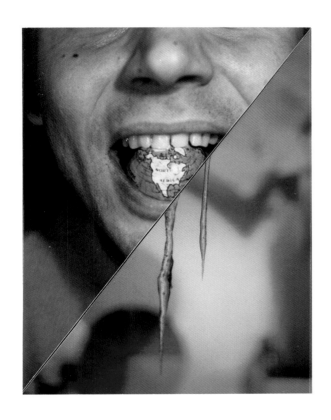 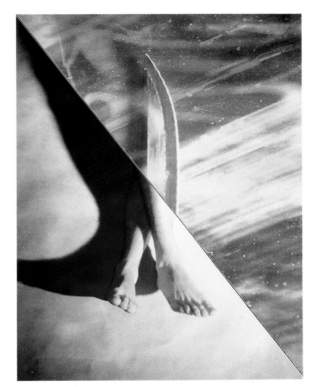 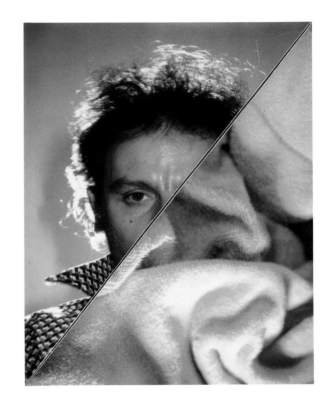

# Photo-Transformations

Samaras's work is autobiographical, but not in the sense of being about daily life. We do not watch friendships grow and fail, or witness the hero's wanderings, losses, reconciliations, and regenerations in the objective, peopled, and contingent world of realism. Instead, the world is drawn into the apartment and suffused with Samaras's presence; the hero suffers and prevails in a place that appears as an emanation of the self, the milieu of spiritual autobiography. But Samaras only discovered a photographic confessional mode when he learned to see the images of his body's surfaces as material to be manipulated directly and, in the stillness of photography, into permanent form.[11]

In one of the Grids, hands knead a stomach as if it were clay. The pictures propose this body to our eyes as both a source and a detail of sculpture, bas-relief fragments in the grisaille of black-and-white photography. They are provisional sculptures, photographic proposals that are, in art-historical terms, only conceivable after Spoerri's "snare" pictures, Segal's plaster casts, Rauschenberg's Bed, or Samaras's assemblages—sculpture that itself, perhaps, became possible only with the age of photography. Samaras's face and body were in his sculpture (and in happenings and Segal's sculptures) before they were in his photographs; they had become public material. Samaras's great opportunity to give the photographic image of his body the illusion of plasticity came in 1973 when John Holmes, an employee of Polaroid Corporation, gave Samaras and other artists the newly invented Polaroid SX-70 and asked them to experiment with it for an exhibition at the Light Gallery in New York.

The SX-70 system is now everywhere in amateur use. The camera ejects the plate immediately after exposure, and the image develops slowly, protected by a tough transparent plastic skin and an equally tough opaque plastic back. The print's appeal to an artist is its deep, saturated, gemlike color and its ambiguous nature as object and image. The image is not directly on the surface, as in traditional prints, but lies beneath the transparent skin—that is, literally on the other side of the picture plane, and literally embedded in material. It has real *and* virtual depth, physical *and* optical presence. Samaras calls the SX-70 "one of the greatest gifts anyone could give an artist."

He discovered that while the image developed, the emulsion remained soft, and that it stayed soft for some time. By pressing and pushing it with a wooden stylus or the rounded end of a metal ruler he could elongate a body, split a chest, cover a wall with markings or a whole picture with the semblance of brushstrokes. Now the *image* of his body became a plastic material and gives the illusion that the body from which the image was taken is as plastic as the body in the photograph.

Arnold Glimcher, Samaras's dealer, has written, correctly, of the SX-70s: ". . . these transformations exist as a kind of improvisational theatre of painterly expressionism."[12] But for all its connection to painting, the SX-70 print is not blank like a canvas waiting to be filled. It offers an image of a literal world, and this image with its temporarily soft material is to Samaras what the world is to the photographer, a set of provisional appearances full of potential pictures. But because the image is of himself, it is an image latent with fantasies, memories, and fears.

"When I say 'I,' " writes Samaras in *Samaras Album*, "more than one person stands up to be counted,"[13] and the AutoPolaroids have already given many of them shape. He has lived "the glory-crowned life of Christ, George, and Michael,"[14] and impersonated the "angels and saints of the church icons" in Kastoria, especially the "hermaphroditic ones,"[15] and reimpersonated the "emperor, bishop, . . . ghost, [and] cloud" he played as a child, draped in "nightgowns, . . . blankets, tablecloths and sheets."[16]

But Samaras also remembers "hearing about murdered Turks buried in the foundations of the house across the street, or about the . . . Jewish quarter where they would take juicy unsuspecting Christian boys, stick them with pins and drink the blood."[17] "My grandmother . . . told me many stories of Turkish atrocities . . . and . . . [in] my history class was the story of a Greek revolutionary . . . who was captured by the Turks, spitted from the ass and roasted over slow-burning coals. . . ."[18]

Scenes of animal and human mutilation haunted the boy in Greece: his father's ritual slaughtering of the Easter sheep before the war, and descriptions of the bloated bodies of two drowned cousins. He connects the death of his maternal grandmother and the worms of her grave with a cat that got impaled on "the spiked top of an iron fence . . . and remained drooping and dripping . . . until she stiffened. . . ."[19] During the Greek civil war after World War II he saw the body of a dead Communist tied to a tree and heard of soldiers bringing severed heads to

town. One night communist mortar shells hit his house. "There was an open gash in the ceiling. . . . My aunt had a serious gash on the side of her belly. My grandmother had two fragments in her lungs . . . [and] died in six days."[20] "If only memory had spatial extension. My mind's childhood is tugging at my tailbone. . . ."[21] He adds, "I want to sweep my mind of meaningful but stale magnetizing trash, to neutralize, infinitize [it] and to let something else take [its] place."[22]

The SX-70s answer this urgent psychic need, project memory into space, give it shape, and for a time seem to detach Samaras's haunting recollections from himself by embodying them in imagery. In the photographs reds and greens play across the kitchen like the colored flashlights of German soldiers in Kastoria; yellows extend from Samaras's memories of wartime skin jaundiced by antimalarial drugs, and of "Gold. The glitter in churches."[23] Deep blues and reds are taken from memories of icons and laid over fabrics and walls. Seeing the photographic image of his body surrounded by the colors of his past, Samaras sculpts it into the dismemberments of his early fears, the severed heads, the trunkless limbs, rent torsos, and pierced martyrs. Into his mouth goes a hand, mottled red and purple like a slab of meat, and he devours himself and reenacts the feast of worms he knew all flesh is bound for. His embodied memories prefigure his own death, and lest that fear overwhelm him he turns the embraces of previous double exposures into ritual self-sacrifices, becomes sheep to his father's knife. He sinks into the "strangulation" of the "primordial slime" that he associates with his birth;[24] only a hand, an eye, a mouth rendered in photographic clarity buoy him up above the swirling painterly morass. Elsewhere the material becomes a cross and Samaras is absorbed into the religious terrors of his youth. Because even the soft SX-70 material will not let him transform his adult body and bearded face into the face and figure of the child, he projects a boyhood picture of himself onto his genitals and buttocks.

This too is a mutilation: Samaras is headless, and on the projected face a penis hangs where the nose should be. But it is comic, a caricature, a repetition of the child's taking the image as fact. In other images the hero melts in grief; he is consumed by anger, stretched to the limits, twisted in agony; he caricatures his agony by making literal our metaphors of pain. Another image of the child, alone, projected onto venetian blinds, stares modestly and soberly into the kitchen; he is at once the childhood spirit of the place and the precocious judge of its grotesque metamorphoses—an image of Samaras's multiple roles: model, artist, and critic; child and adult.

"I wake up," he writes, ". . . and I think, why should so much torture be focused on my conscience?"[25] And, "Enough talk about [the past]. My dreams are overstuffed with [it], so why should my autobiography be? There must be some distillation, some further process that will wash away their taste. . . . How do I sublimate them? How do I shrink, shrivel, and stuff them in my back pocket?"[26] The comic edge of caricature is the artist's means to distance the terrors his hero conjures up and succumbs to.

The miniature form of the SX-70 is a means to diminish fear. Color also distances. The colors of the kitchen are not modulated, as they are on the human figures. Flushed like slapped flesh, they are also tonal, like the grays of black-and-white photography, and thus prosaic. They transform neither the kitchen's sharply outlined objects nor the plainly textured surfaces of its appliances, walls, or fabrics. They are theatrical, but not disfiguring. The hero does not take the room down with him, or fill the cosmos with his romantic agony.

These photographs are not about the desire to be someone else. Nor does Samaras try to duplicate specific childhood sights—an icon, or the "muddy, coarsely clothed, unshaved body" of the dead Communist, with "flies [and] red blotches . . . holes of entry for the bullet."[27] This too would ring hollow in photographs. The SX-70s do not parody appearances. They disclose instead the broken, twisted, unlovable shapes the self discovers when it looks within, and records them with the adult's dual understanding, which knows the fears to be at once histrionic, ridiculous in men's eyes, yet insurmountable, all-consuming. The theatrically colored kitchen has the look that places have when the soul is moved.

The hero is without blood, gore, or horrible ragged flesh, and the intense coloration beautifies the most severe dismemberments. "There is a difference," Samaras writes, "between a dead ugly and a dead beauty. The dead beautiful are magical, aloof, clean and monumental. The ugly dead are revolting, semi-human and impolite."[28] Samaras's childhood religious fears were "a kind of aggressive poetry";[29] his grandmother's stories of atrocities gave him "pleasure";[30] the terrors of his childhood

were compelling, transfixing, erotic. "Didn't I also identify with the |icons'| serpents and dragons that had swords and lances thrust into them to make them contort and spit blood? I wanted membership into the saintly beauty-drenched club."[31]

The saturated hectic SX-70 color, independent of whatever specific memories it invokes, gives each scene a jarring voluptuousness. We cannot square it with the grotesqueries and self-indulgences it coats. Our responses are further confused as Samaras treats his malleable SX-70 body as a storehouse crammed with the adult artist's art-historical memories and reinvests his hero's fears with their original erotic and aesthetic intensity. He sculpts himself into Giacometti's figures, nude Greek athletes, scalloped nineteenth-century bronzes, Van Gogh's face, figures from Poussin and the School of Athens, and Christs, heroes, and martyrs from centuries of painting. They consume each other, merge with each other and beget grotesques.

Samaras measures himself against the dead greats. Neither free from them nor entirely absorbed by them, he embodies every artist's fear. Thus he conflates his childhood terrors with the adult artist's anxieties, and, like the child, he is voluptuously drawn to them. In his autobiography we discover something of what drives him:

"What a thrill, what a magnificent ejaculation it would be to create a |religious| tradition, a way of coping with imagination and daily life. To lift the basic ingredients, reduce them to some sort of original power and redo the thinking of humanity, my thinking. . . . I have only one life to live, let me live it as a mutant."

Glimcher remarks that Samaras's color is "reminiscent of the cartoon world where steamrolled characters spring back to life again, denying mortality."[32] But the Roadrunner's Wily Coyote and Tom and Jerry's Tom never catch their prey or satisfy their desire. They are fated by the episodic structure of their fictions to patch their shattered bodies together, build another elaborate machine and let it become the instrument of their own mutilation. Wolf Man must always sink into bestiality and be destroyed until his next cinematic resurrection. Likewise, Samaras's comic-book heroes are continually destined to doff their everyday disguise, shine, triumph, and wait for the cycle to start again. The martyred figures from high art—John the Baptist, Holofernes, Saint Sebastian, Christ—and damned souls from

Bosch, through whom Samaras pictures and experiences his death and dissolution, are preserved by art at the height of their transfiguration. In myth, Narcissus must always drown and bloom.

The SX-70 allows Samaras to deal with his body as material, but, ironically, the moment his character becomes a recognizable figure from myth, entertainment, or art, he exhausts the possibilities of materiality that momentarily were his. Samaras wants to rid himself of the beings of his imagination. "After all, I am an individual with a distinct existence." But in the frozen moment of the photographic episode, and in the guise of characters whose ends are preordained, he is cut off from self-development. The character's descent is not an exorcism; he is ambiguously self-created and self-denied, at once triumphant and lost in art and the past, forbidden any sense of future.

The artist, however, by picturing his kitchen nightmares in the terms of public, historical art, lets us understand his fears as versions of our own; and the eclecticism of his artistic allusions lets us see him as our contemporary. Contemporary, too, is Samaras's confessional mode, which has its literary counterparts in the poetry of Robert Lowell, Sylvia Plath, John Berryman, Denise Levertov. And at the same time that Samaras made these photographs, younger Americans sought visions in hallucinatory drugs. They also ceremoniously exposed their nakedness in public and their sexuality in group lovemaking. Softcore pornographic magazines, appearing at about the same time as Samaras's photographic work began, regularly featured snapshots of men and women in their homes, naked and spread-legged. Gay culture went public. In the classified sections of intellectual journals, academics and professionals looking for sexual partners advertised their precisely articulated erotic tastes. Samaras draws these strands of public confession and display into his art. He unites them with atavistic guilts and fears over which the American pageantry of self rode roughshod. He thus impersonates myriad self-obsessed cultural figures as himself and restores to them anxieties they assumed to have vanished. Not only that. By picturing these self-mutilating anxieties in terms of art, Samaras restores mythic dimensions to a cultural present in the process of detaching itself from history.

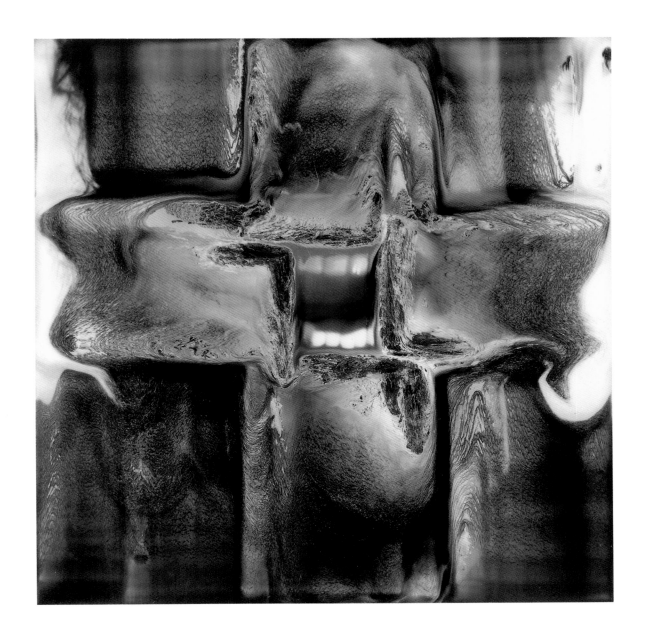

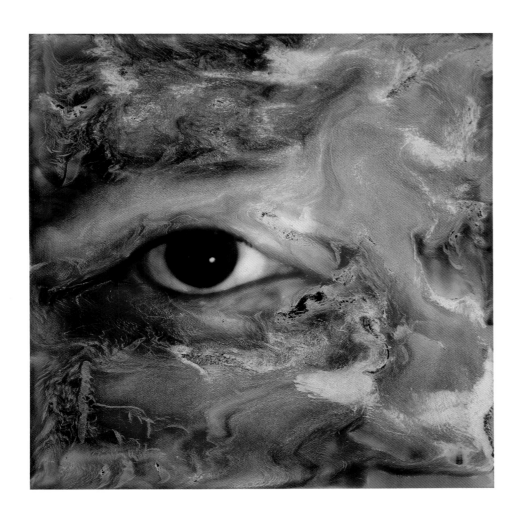

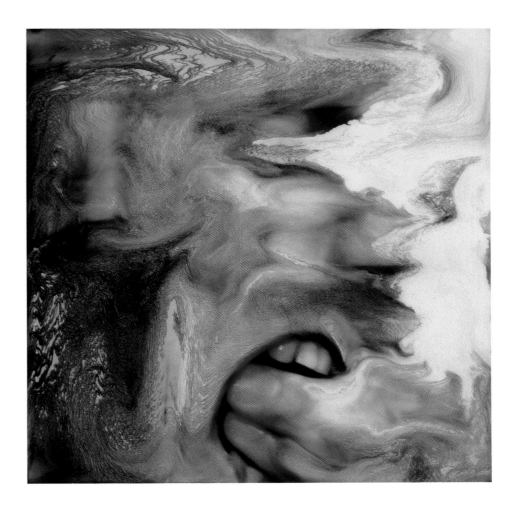

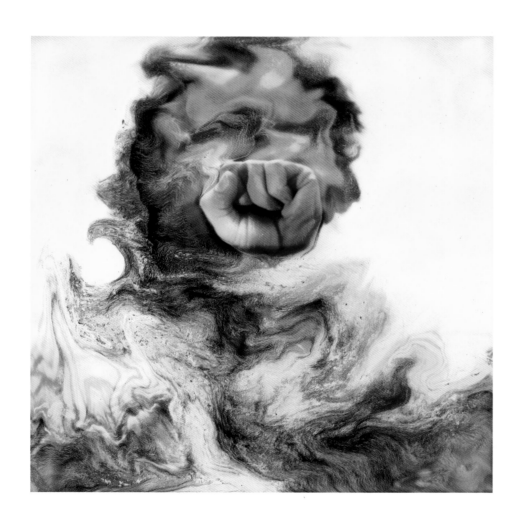

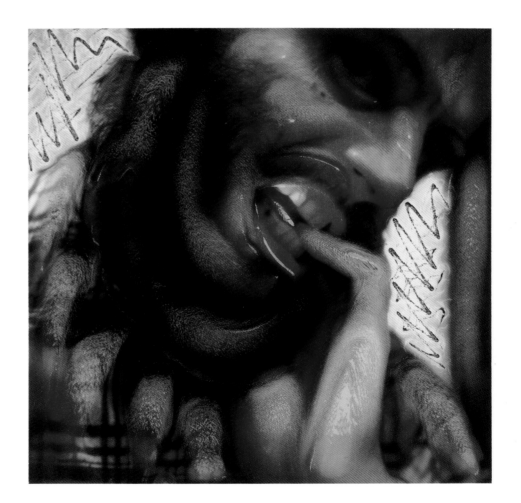

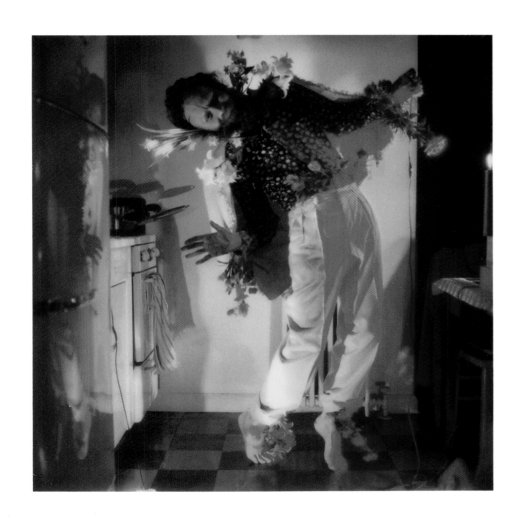
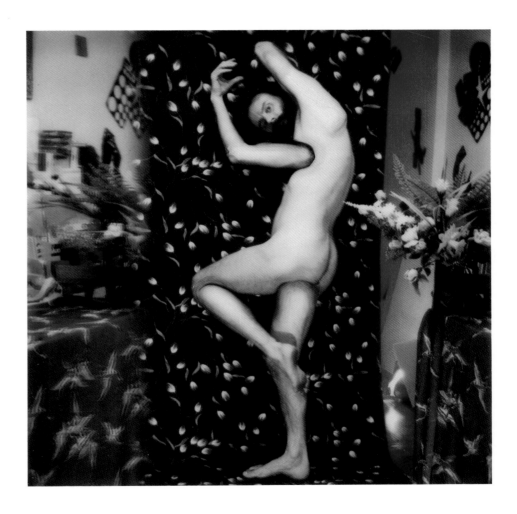

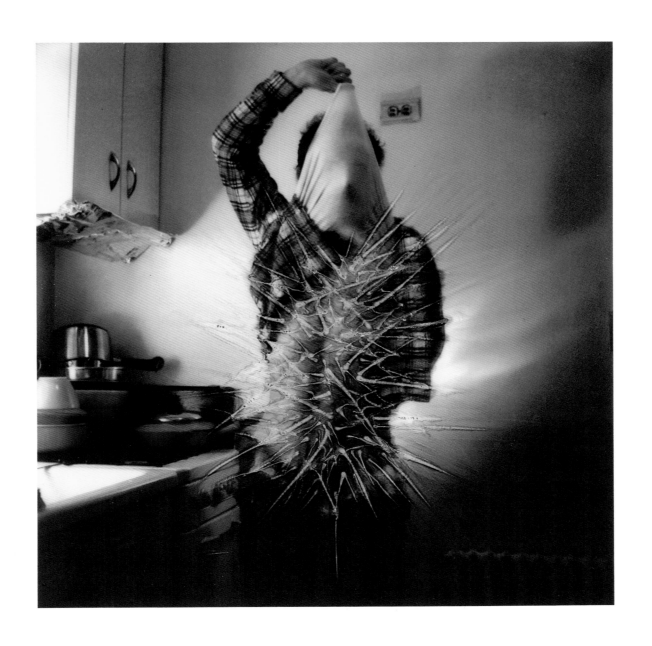

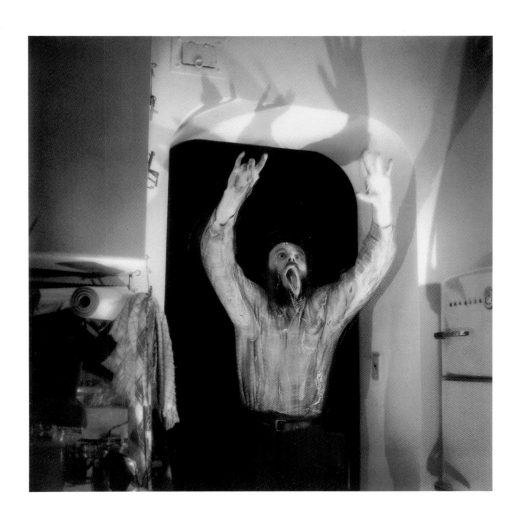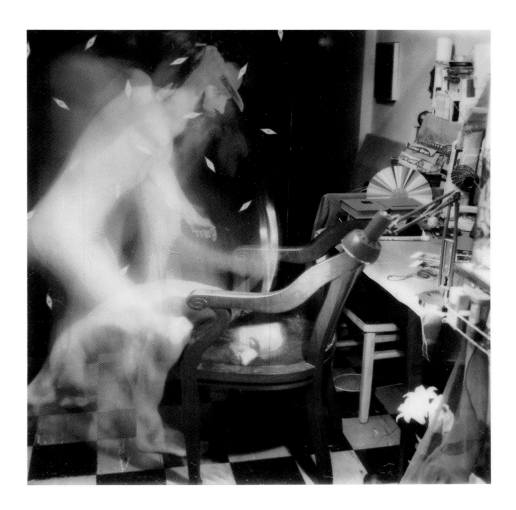

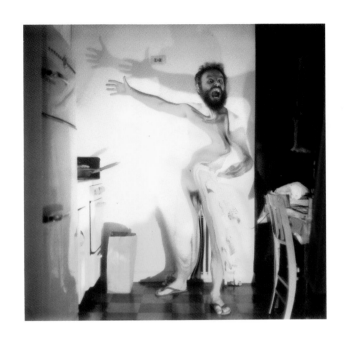
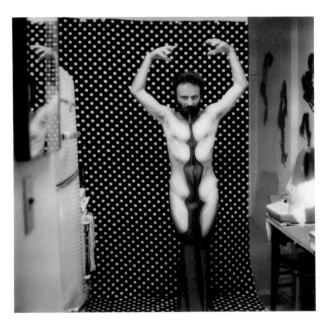
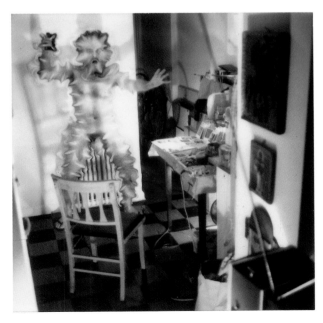
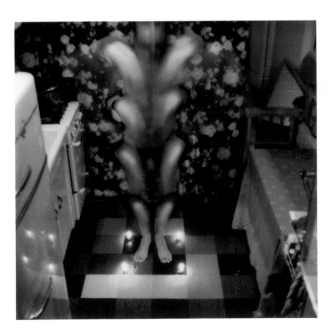

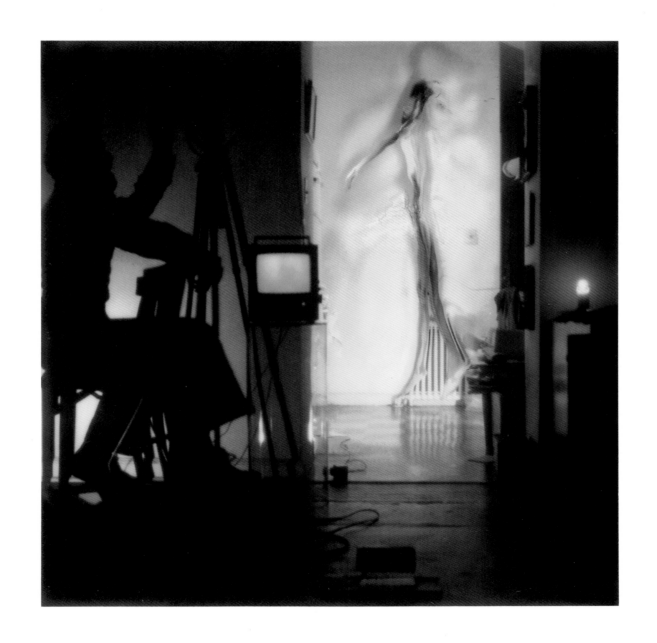

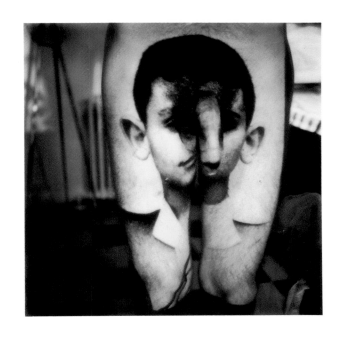 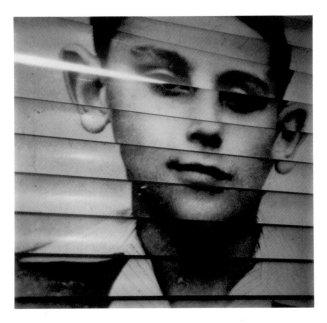 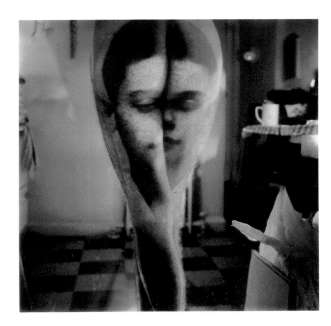

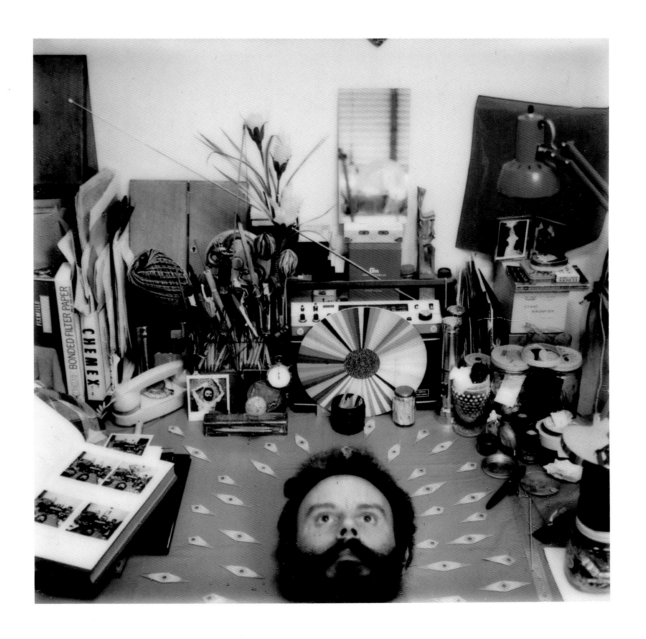

# Still-Lifes & Figures

Each phase of Samaras's photography is a single episode, each poses a facet of a single action that is multiplied and elaborated, but not developed. His episodes end with the hero unchanged. With each successive episode, however, style, presentation, and the hero's agon change dramatically. Previous episodes return to our memory, we chart the hero's development retrospectively. This is the retrospective irony of photographic works without heroes: Walker Evans's *American Photographs* and Robert Frank's *The Americans*. Samaras is the first to apply it self-consciously and at length to a single character and thus to attempt what is perhaps the only first-person novelistic form available to photography. This was unintentional, and only discovered by Samaras as he explored the potential of each technical innovation handed to him.

In 1977 Polaroid Corporation developed an 8 × 10-inch color material and asked Samaras to use it. In this new material the image is on the surface, as in the gelatin print, and its delineation is precise, its descriptions detailed. To manipulate here is to trespass. Samaras's handwork dwindles, and his mutiple exposures become almost seamless. With the new material, Samaras turned toward a photography of facts.

The Still-Lifes describe the most realistic space of Samaras's photography. The centered compositions of the AutoPolaroids disappear; so do the framing devices of the SX-70s. The grid has been internalized and further complicated as scores of glittering objects and saturated colors scatter points of optical intensity everywhere.[33] The arrays in the kitchen seem to stretch toward infinity; each picture seems merely to point at a swatch of an endless, seamless fabric. Frame and vantage point serve clarity. The erotic intensity of the light and its colors seem to flow from the objects they illuminate. Kitchen, light, color, and objects seem to organize themselves, to participate in the ceremony of display, like the vernacular still lifes of documentary photography—the unintentional artworks formed by objects in corners of Walker Evans's sharecroppers' cabins or Atget's window displays.

As Samaras's kitchen is reclaimed by reality, our responses to Samaras's work are divided. From the perspective of the hero's new situation we immediately reevaluate his past. In the SX-70s the hero could not entirely lose himself in fantasy or materiality. With each descent into a metamorphosed self, each dissolution into swirling matter, the objective medium of photogra-

phy drew the character up short and connected him to the physicality of the body and the apartment. Even when he seemed most submerged in melting pigment, a hand, a mouth, an eye—touch, taste, sight—held him in the world. From the Still-Lifes' perspective, the hero of the SX-70s is in anguish not only because he sinks into the bog of self or vanishes into metaphor, but because he can't escape his body or the contingency of his person. In the Still-Lifes we see that Samaras's SX-70 hero had another choice, which was also foreshadowed in *Samaras Album*:

"When I am alone in the apartment ... I ... stay slightly still thinking, existing alongside my utensils, furniture, materials, walls, surfaces, spaces with an erotic freshness. Because I don't understand them, because I don't exhaust them, because they are always there ... [they] are thought extracting. My apartment is a reality that absorbs, challenges and soothes my mind. It is a springboard to my fantasies. It doesn't emote, it doesn't insult, it doesn't provoke those infancy-connected love-hate collisions. ... I can enjoy objects, surfaces, edges, metaphors, abstractions as I like. There is no competition. ..."[34]

With the Still-Lifes, artist and hero attempt to reconcile themselves to reality.

In the Still-Lifes, the kitchen's diversity and complexity are the world's. Scattered about are materials and objects of Samaras's art, with their allusions to art history. A vulgar tablecloth, printed with odalisques, refers, through Delacroix, to nineteenth-century imagery, orientalism, Africa. A photograph of Kastoria on the wall brings in Europe, Greece, and antiquity; Superman and high-tech appliances refer to modern culture, brand-name foods to everyday life; and collections of beads, glassware, and bibelots unite the kitchen with taste and greed. The kitchen is spinning through the same universe that contains the spiral nebula in a photograph on the wall. Adopting a documentary idiom, Samaras seems to let these objects speak for themselves. The artist seems taciturn, the kitchen eloquent. But the hero is there, strutting, crowing, snarling, melting. Believing in the fiction of the Still-Lifes as reportage, we again see the hero's paradings as charades. We see his distorted face and naked body in a large sheet of silver Mylar, but we do not believe that one of the SX-70 creatures has dropped in for a visit. Instead, we see Samaras posing as a former self. The table, with its opened fruit and glinting knives, its surrounding nuns and goddesses, demigods, and ritual celebrants, is an altar, and Sam-

aras its victim-priest, in metaphor. Shown the prospect of heaven, tempted and threatened by women, solaced by virginity, mocked by comic-book heroes, Samaras is a protagonist only in photography's poetry of fact. In robes and Hawaiian shirts, he reenacts the heroes of his portrait heads without their heroism.

The kitchen's density of experience, color, history, culture, and extravagance overwhelms the character's theatricality; its rapid metamorphoses surpass his invention; it, not the character, is heroic in its constantly changing being. It holds, in metaphor, an array of human possibilities: athletic grace, the contemplative life, sexual love, marriage, melancholy, devotion, fantasy; in the figures of birds and flowers, it dreams of nature. Against this breadth Samaras's hero still plays at melodrama. His theatricality becomes grandiose, and anger on the hero's face strikes us as the anger of the unmasked braggadocio.

The artist, in sympathy with his hero, confronts the apartment's virtuosity with photographic irony. The objectivity of his idiom describes each object not only as itself but as a resemblance—nun and Diana, golfer and odalisque, nebula and city. Puns and echoes pile up until everything seems a version of something else. Moreover, most of the objects are mass produced and refer to their countless doubles elsewhere. The Still-Lifes are catalogues of objects as doubles; thus Samaras the photographer debases each object's originality and substance.

Not content, Samaras levels this irony against the photograph itself. Among the artist's materials—pencils, rulers, lights, scissors—are several empty cardboard mats. Within their frames the kitchen organizes itself haphazardly into little pictures, which are echoed by other chance pictures within the borders of mirrors, magnifying glasses, open cabinets, and shiny metal surfaces. The photograph, as picture, is thus absorbed into the fabric of imposture.

The Still-Lifes here might also, therefore, be pasts in relation to other photographs we do not see, approximations, not finished works; each Still-Life might itself reappear in yet other photographs. Their authenticity is flawed, their documentary status suspect. The images that dwarf Samaras's hero lose their authority.

If the artist had stopped here he would have created himself as the author of his own irony and self-parody, a man who an-

ticipates and shares our knowledge of his hero's limitations. But he presses the attack and deposits photographs of himself throughout the kitchen. He is also sometimes multiplied by double exposure; and, as we have seen, he revises earlier selves. But as pimp, transvestite, or self he is a double of doubles, a mockery of mockeries, a parody of earlier parody.

Samaras is the parodic object from whom all parodies flow and to whom they return. When this narcissism parodies itself, it is wearying. In an ironic revision of the early black-and-white double exposure, Samaras turns away from himself as if bored with his double's drab histrionics.

But Samaras also turns to himself for help. In another reprise of the same early snapshot he rejoins himself and guards himself against the world. Behind the two figures is the void, before them the world and our gaze. Samaras is clothed and seeks protection within the self. But each figure looks away from the other; they don't embrace; narcissism has failed.

In this photograph, between Samaras and the world is a bust of Dante, the poet's head sprouting grotesquely from his book. We see the figurine in many Still-Lifes, and in four of them Samaras imitates it directly. Dante's is the other artist's face to appear in Samaras's work first. Among all the faces in the Still-Lifes—Superman's, the nun's, the odalisque's—it is the most important one after Samaras's.

Like Dante's, Samaras's art is episodic and vernacular; it asks an objective form to become spiritual self-portraiture. For the Commedia's political exile and secular poet, as for the Christian pilgrim, salvation is in community, damnation in the self. With the appearance of Dante, we perceive Samaras's hero in a hell of narcissism.

As Virgil appears to Dante, Dante appears to Samaras to admonish him, to remind him of fellowship and the world. He casts ironic light on Samaras's spiritual venture and challenges Samaras's art. At the start of the Commedia, Virgil holds out the hope of salvation, and the poem's episodic structure moves toward that future goal. With the statue, Samaras gives his photography a sense of a possible future and challenges his hero to join the world.

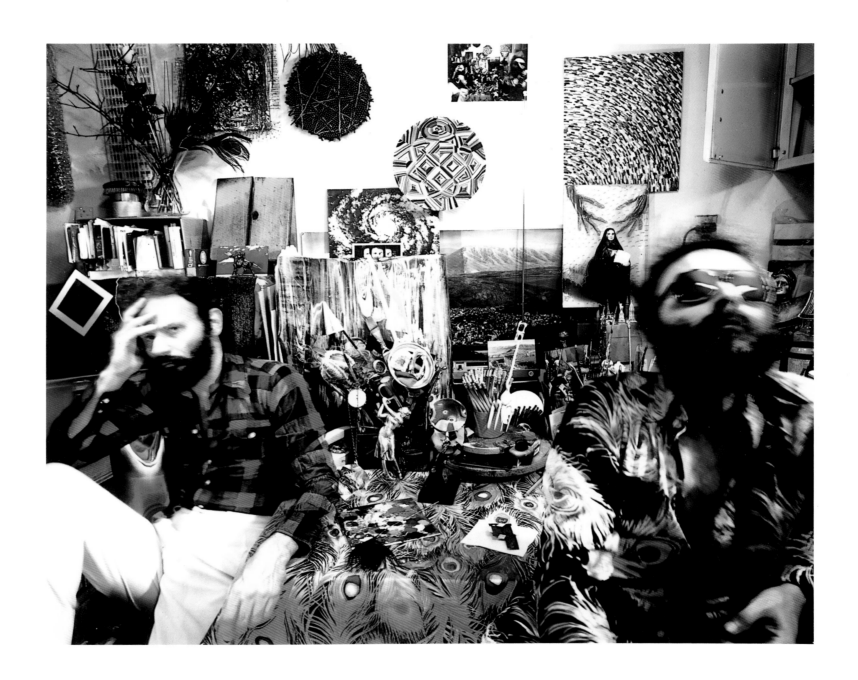

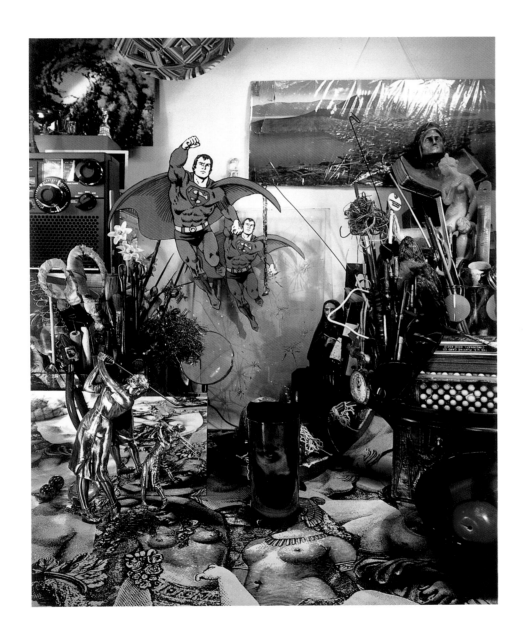

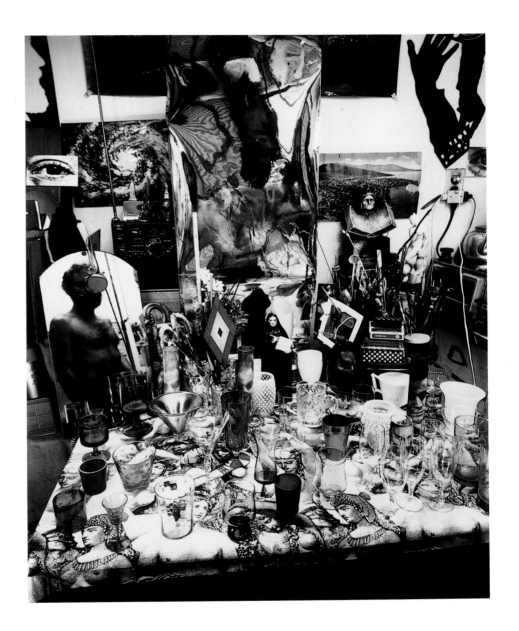

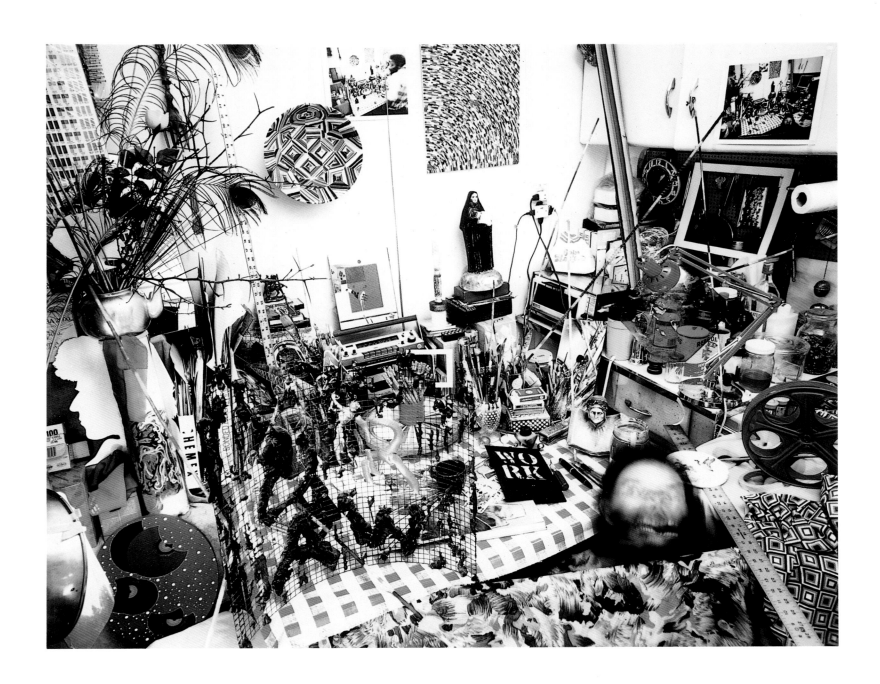

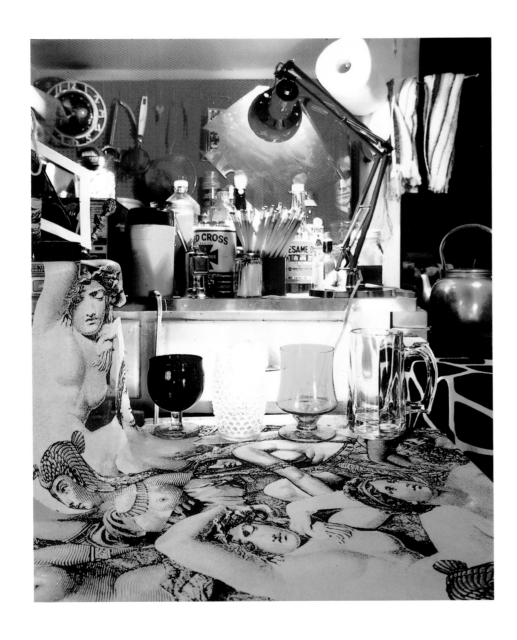
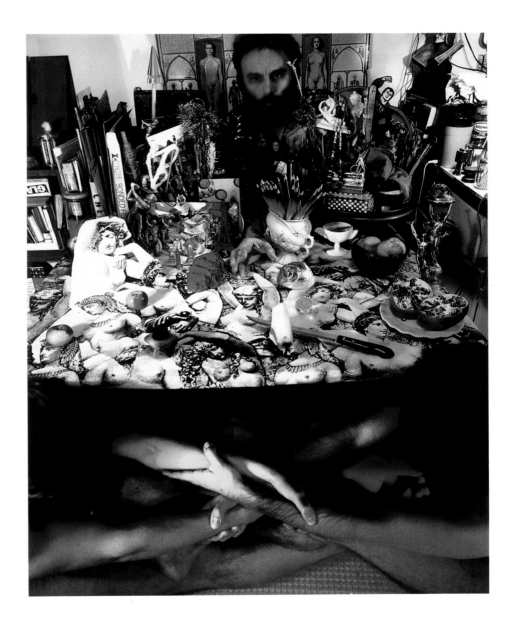

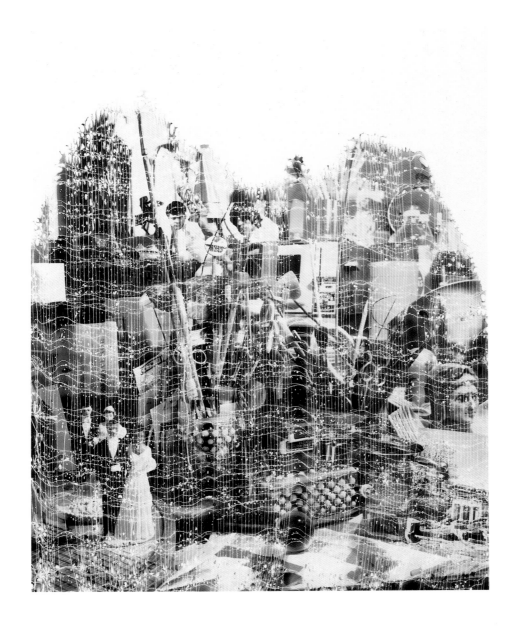

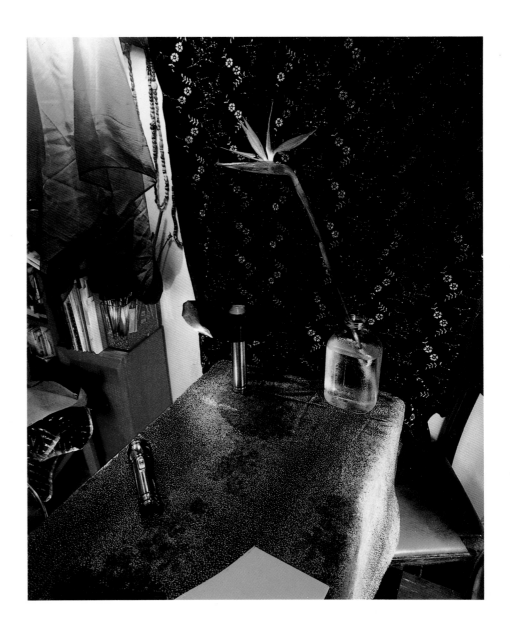

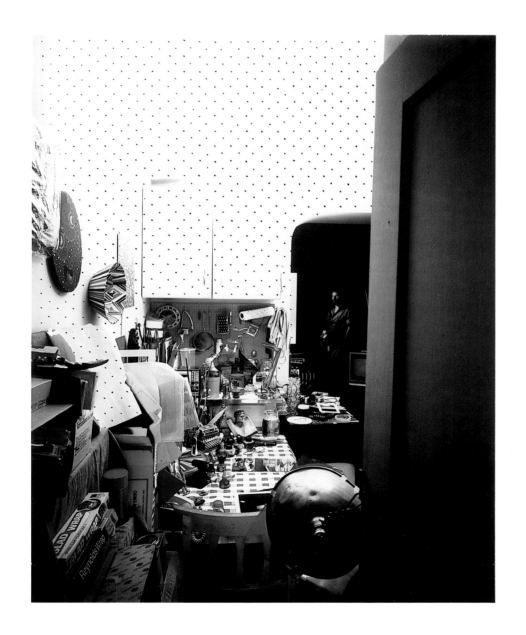

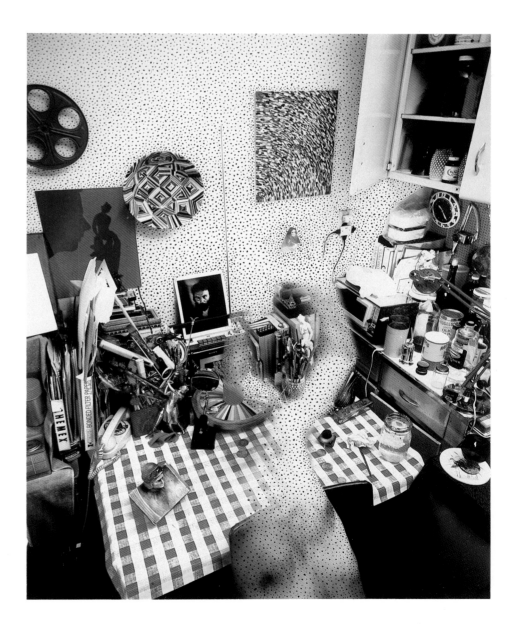

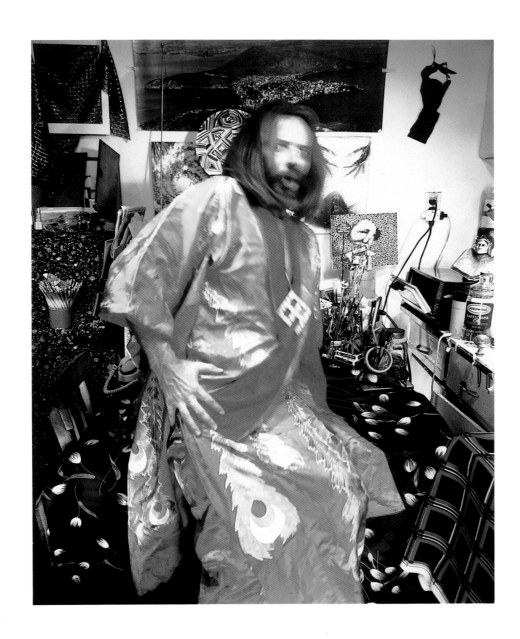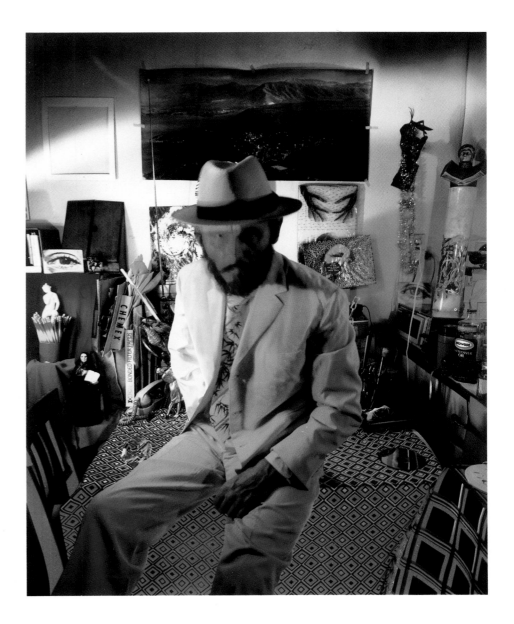

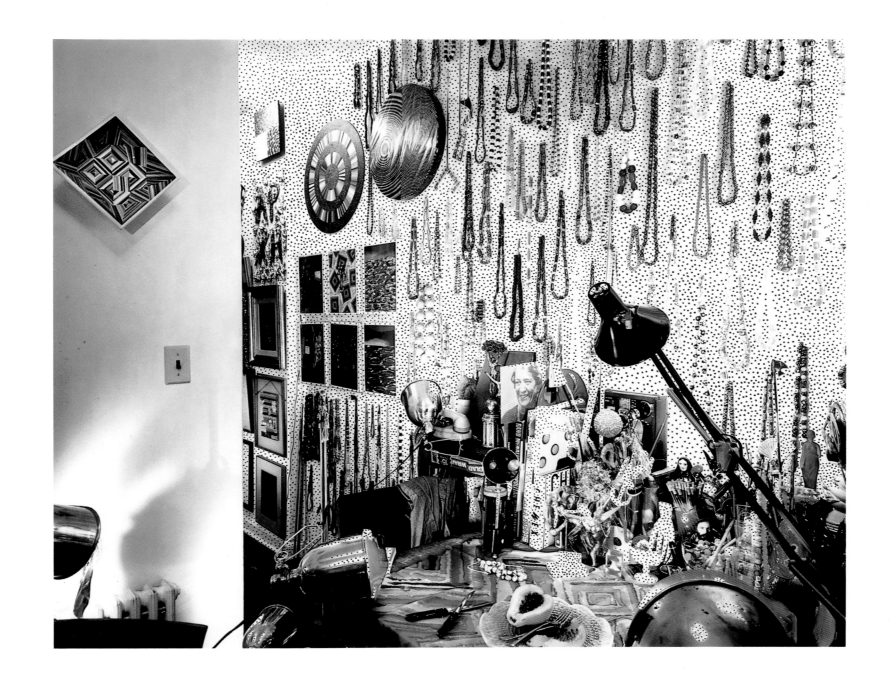

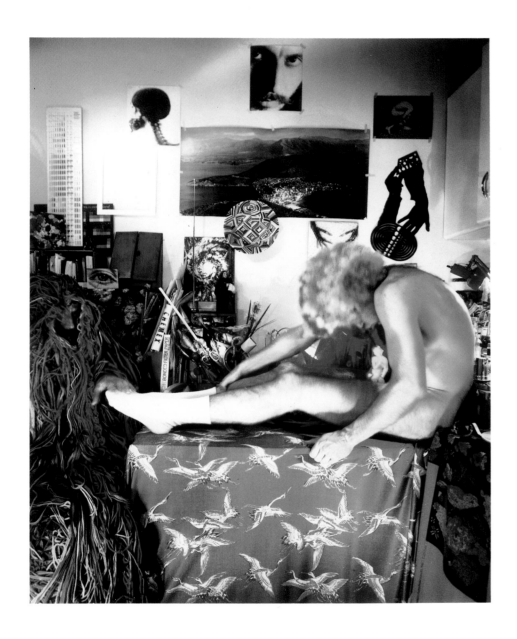 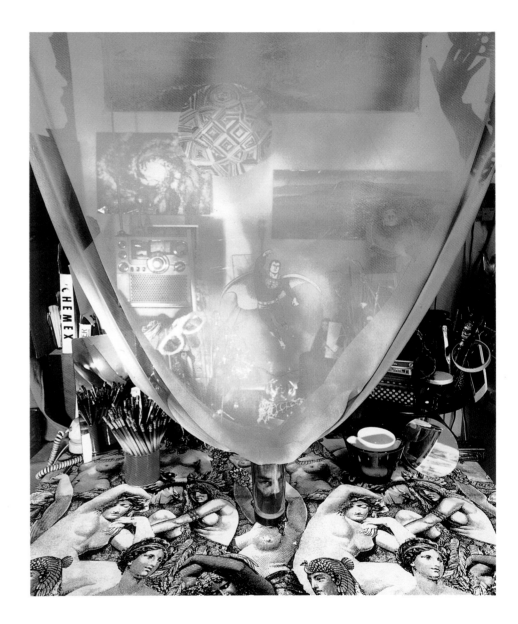

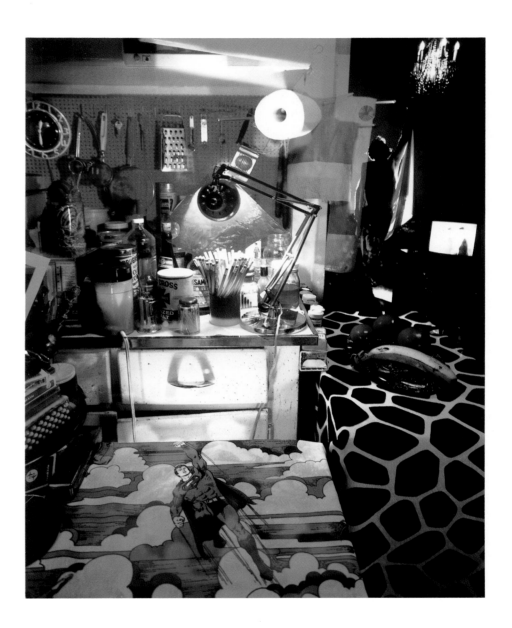

8 x 10 Sittings

When the Still-Lifes were finished, Samaras did not wait for a new material or instrument; he committed himself, instead, to the 8 × 10 camera. Curious about what else it might describe, he took on one of photography's classic problems, the portrait. In 1978, Samaras asked more than seventy-five men, women, and children to sit nude for him. Many of the adults were painters, writers, sculptors, photographers, collectors, dealers, or others seeking public identity in the field of art. Their presence in Samaras's art gives his work a new public scope and his hero a new modesty and risk. Turning outward, Samaras provisionally acknowledges his search for the self as ours; photographing the world, he takes the chance of discovering his true place in it.

Sittings begins as a complex document. It dissociates men and women from their work, name, and place in history, transplants them, naked and unprotected by their fame, to the photographic present in untitled portraits that chronicle only faces and aging bodies. Without their clothes, Samaras's characters also become symbols for the erotic magnetism of the artist in culture, and nude spouses and lovers are muses in the flesh. But when these works appeared, the art world saw husbands, wives, lovers, and children. Sittings therefore documents the mundane erotic lives of artists, the parceling-out of sexuality into the embraces and relationships of active, daily love. It also let the art world know who went to Samaras's studio and took their clothes off for him, knowing the photographs would be shown. As history, Sittings is also gossip. One can imagine some of its photographs in future biographies.

Sittings more than documents a specific event in the New York art scene: it adds a chapter to photographic portraiture's long tradition of public posing and public style as a version of social and historical self-creation.

Samaras's adult sitters went to his studio as former aristocracies went to be portrayed by Holbein or Van Dyke. To be figured amid his works and to pose naked "after" Samaras is to be certified as members of their social and artistic world. But to use him as a means of their commemoration is also to acknowledge that they have placed him in their pantheon. Not as Lucas Samaras, former student, fellow artist, commodity, friend, host, or character, but as Samaras, a disembodied symbol for a cluster of stylistic and psychological concerns that have helped shape an artistic era. They grant him in their beings the desire he has expressed in the myriad figures of himself in his art. Samaras's face at the edge of the frame, always in the same place, is proof, like a signature, that the sitters are not posing in fake Samarases. He stands there in turn to accept the laurels their presence brings. But because we know that Samaras asked everyone to pose, we read Samaras's presence as a confession.

Samaras's adult sitters are older artists whose work pointed the way. They are also teachers, publishers, editors, curators, dealers, collectors, and friends who supported him in many ways. They are his patrons, spiritual and secular, and he acknowledges their help by repaying them as Renaissance painters repaid their patrons, by enshrining them in art.

The chair, the colors, the light stands and reflectors, the shadows, and the poses interrupt the bodies' forms and reduce them to parts. Legs like marble columns stem from dwindled trunks, shriveled arms from chests broad as plains; knees bulge like breasts from a man's chest. Shoulders flatten into slabs, hands sprout from waists, feet from thighs. When two people pose together, the arm of one will so create the body of the other that it seems absorbed into a body not its own. Between two seated women a knee appears that cannot, in the scale of things, belong to either one. Colors end at borders that are not the bodies' creases, joints, or contours. Morgue blue, rust orange, burnt red, incandescent white, and green like decay, the colors at once give the bodies a lavish, erotic optical intensity and distance them from flesh and form. Flesh becomes material, like putty, clay, or metal, and these bodies look stuck together out of infinitely specific parts and parts of parts that have been gathering for years in some unphotographed corner of the studio and are finally put to use.

Samaras gives his sitters the beauty specific to the photographic portrait, physical singularity according to the singularity of his obsessive style. But in this they risk a loss of singularity by being absorbed into his art. Samaras's figure in the pictures assures them they will be themselves.

Samaras prepared his living room to resemble the home his sitters knew from his photographs, and filled it with materials and objects that call his other art to mind. The sitters are at once visitors to the land of his photographs and pieces in his assemblages. Like tourists who stand to be photographed in the Piazza San Marco or in front of Notre Dame, they come to a public place and pose with a historic work.

Like irreverent tourists, or children who have not learned that art is awesome, they take their clothes off, step into the work, and pose. Samaras, whose military green costume does not change from picture to picture, stands apart like an ideal museum guard, lets them do what they will, and glowers at us lest we disapprove. Stern to us, he is all tact to them. In his previous photographs he was the naked virtuoso of his realm; here he is the watchman at its border.

Some pose as figures from high art, nudes from Delacroix's *Death of Sardanapalus* or the grotesques of Goya's *Caprichos*; others quote burlesque; in their theatrical abandon, they all quote Samaras.[35] But they do not become him; they become themselves. As themselves, they bring to Samaras's art the emotional density it had lacked despite the diversity of his incarnations. Children are virginal, grave, and shy; old men fatherly, even patriarchal; women brazen, sly, luxuriant, and skeptical; men perplexed, aggressive, pretty. There are pathos, comedy, boredom, candor, distrust; in embraces, bodily havens; in athletic poses, bodily joy.

The sitters' fears are social, not existential; sharp but surmountable. They are the fears of being exposed but not recognized, and are born of the awareness of the camera and, by implication, our gaze. These are neither Samaras's fears, born of the inward gaze, nor his pains, which, like the child's, seem endless. Against discomfort the sitters field dignity, high spirits, endurance, fortitude, bravery—social, public, Aristotelian virtues.[36] Samaras conducts his quest in solitude. Although he needs courage to face its torments, he keeps up no appearances and is free to rage and cry. The sitters acknowledge us; seeing their ambivalence, their need for both privacy and self-display, we recognize their likenesses as ours. The sitters' distance from Samaras's hero preserves their identities as social beings.

Samaras's appearance at the side of these portraits has been called voyeuristic, but this is not correct: he looks at us, not at the sitters. But he hides behind the trappings of his art and is fearful of the social gaze his sitters meet.

Unlike the symbolic objects of the Still-Lifes, the sitters represent not paths to be followed or rejected, but choices made. Other lives, not just other beings, have entered Samaras's fiction, putting his hero at risk. Thus he gives his fiction the nov-

elistic complexity that has eluded it. Samaras has exposed his hero to irony. The risk of Sittings is that in light of the sitters' choices the hero's expedition into the self will be seen as an isolation from fellowship and a shrinking of the self.

The couples, for example, who pose for Samaras confess their dependency on others. They accept the social cost of appearing with another, of letting the shape of another's life determine the shape of their lives and how they're seen, of creating oneself in constant reference to another. Letting another's body press against theirs, they expose themselves to the ambiguity of touch. These are threats the self encounters in daily life; the sitters risk them to gain life's everyday rewards—tenderness, connection, and the mirror, however imperfect, of themselves in the other. Through them the sitters regain pasts and live out fantasies, if only in the artifice of the pose. In Sittings, the grown child feels again the softness of the mother's naked breast, the mother presses the child's flesh once more against her own.

Let us imagine—as photography's ambiguity lets us—that all the couples here are lovers. Then each character who poses has found in life what Samaras seeks in imagery, a bond of narcissism that nonetheless involves another (no matter how close a likeness) and thus fends the isolation of true self-love.

Samaras unwittingly draws his sitters into a fiction he had formerly reserved for himself and asks them to share his obsessions and identify with the self-possessed, sexually flamboyant figures he has earlier embodied. But photography's ambiguity also lets us imagine that Samaras's subjects sought him out as the portraitist appropriate to themselves. Standing in the wings as master of ceremonies, Samaras introduces his characters and lets them play their self-assigned roles. Thus Samaras, as artist, takes his risks. He is like the novelist whose characters take on lives of their own and detach the fiction from the author's will; he gives up the control he had when he was the only player. Yet as the ambiguous figure of his entire photographic work, the artist-hero, Samaras prevails. As artist, he claims these characters as his inventions. As hero, he absorbs the sitters into his imagination; his life now contains others who reflect and substantiate himself.

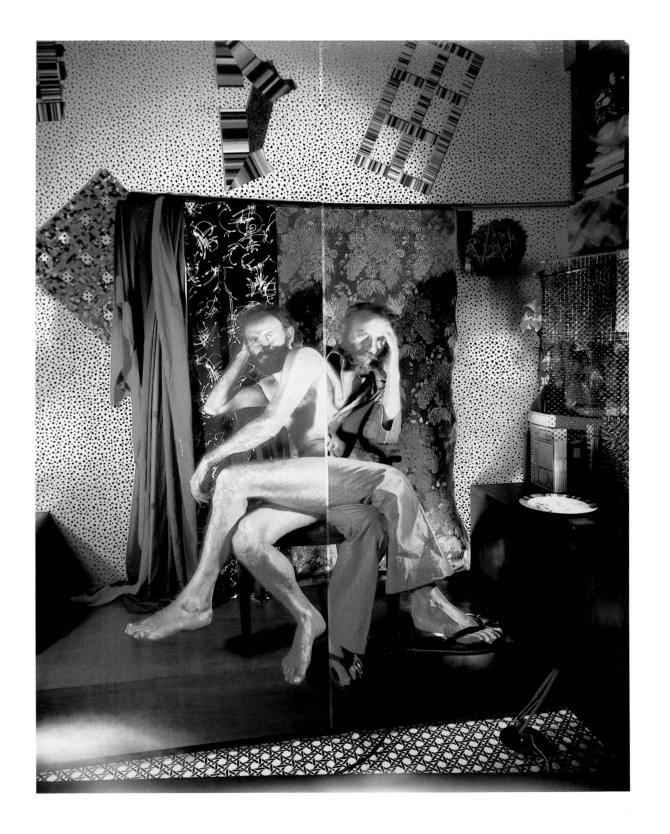

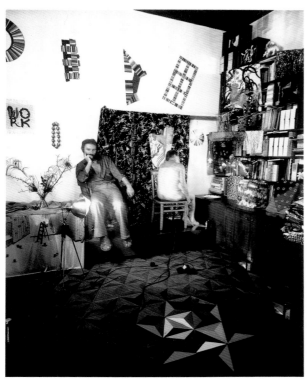 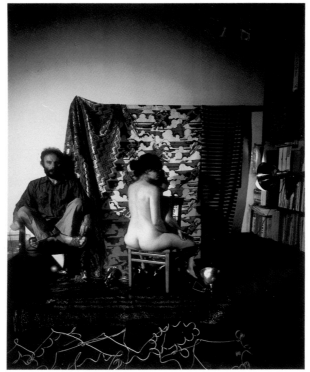 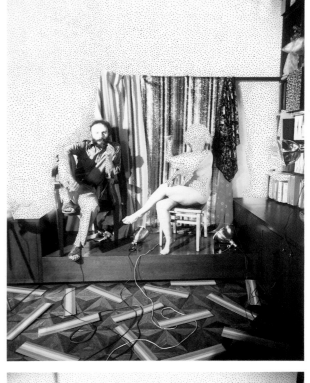

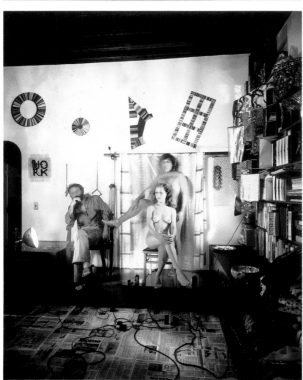 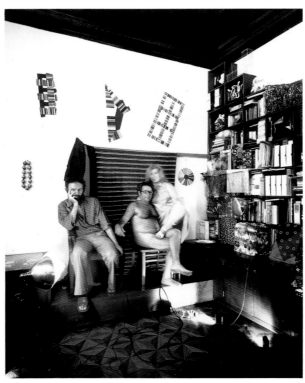 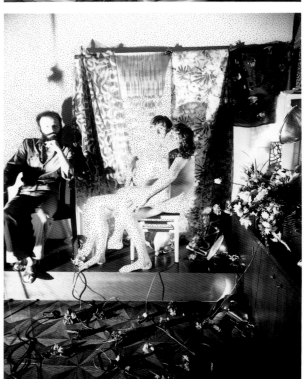

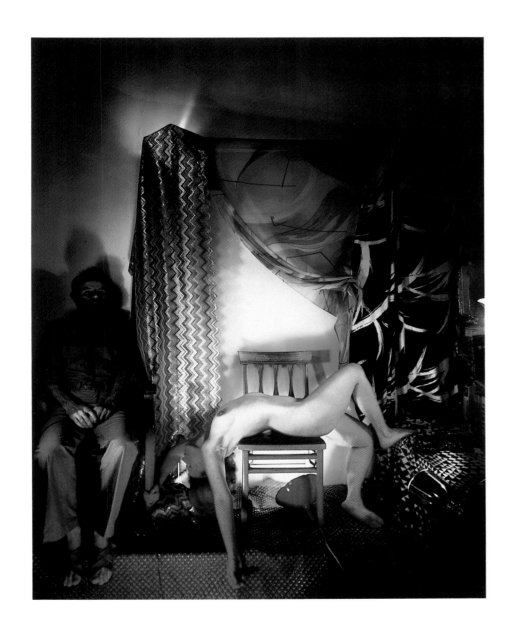

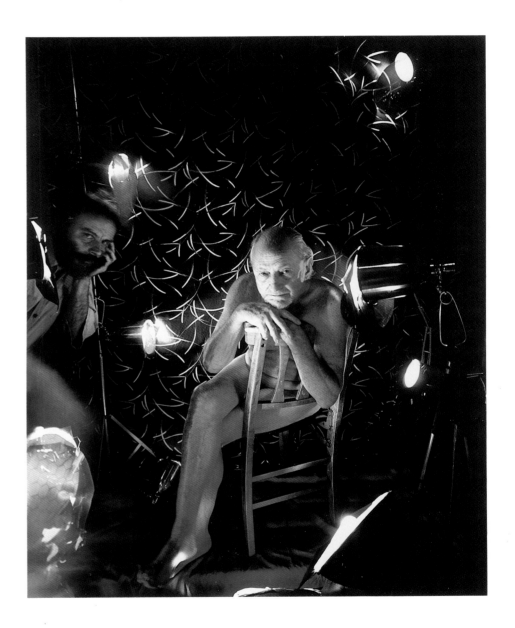

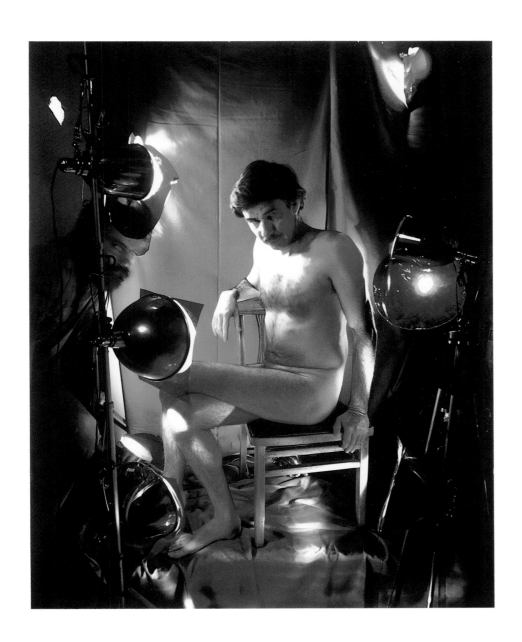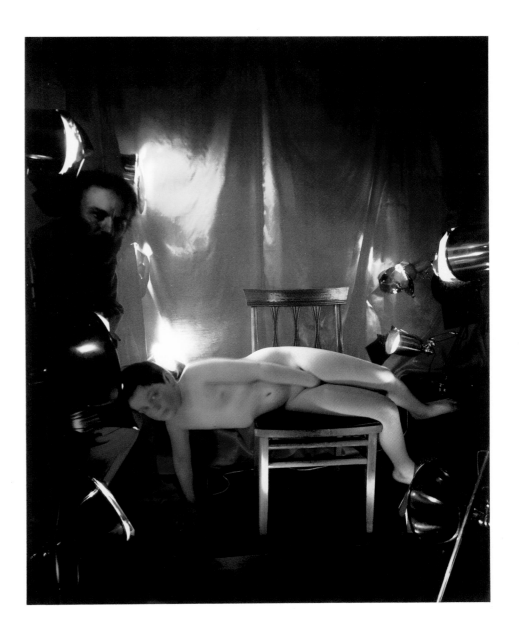

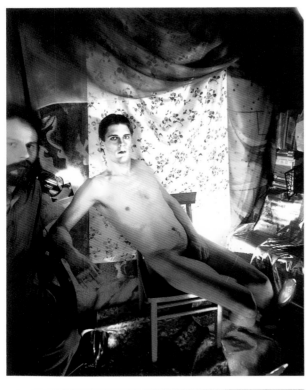
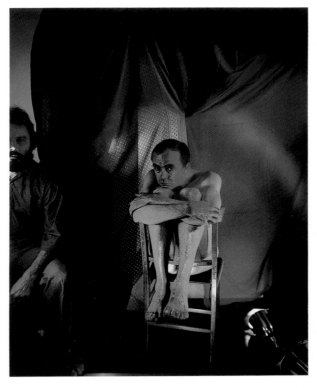
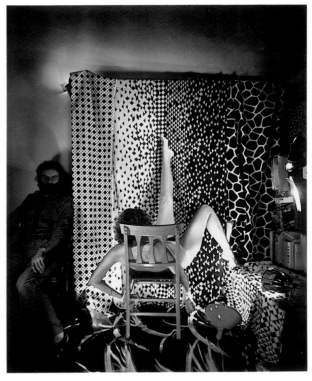
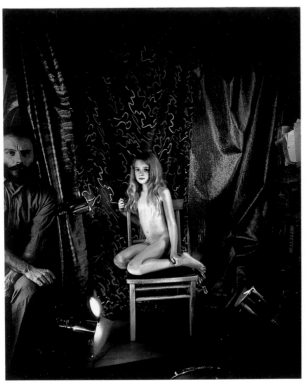
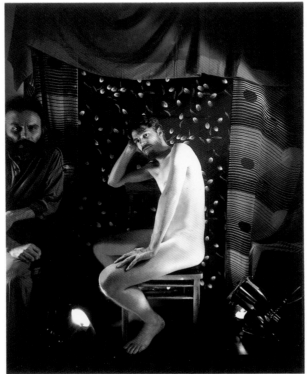
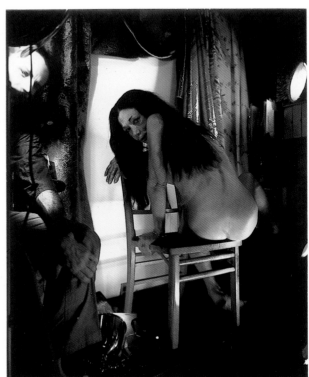

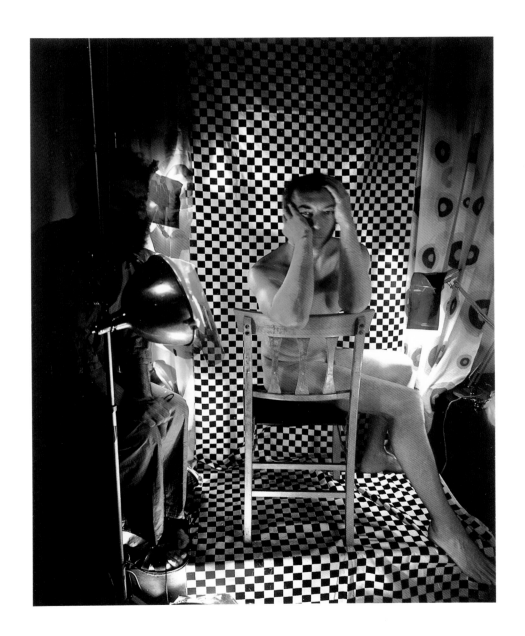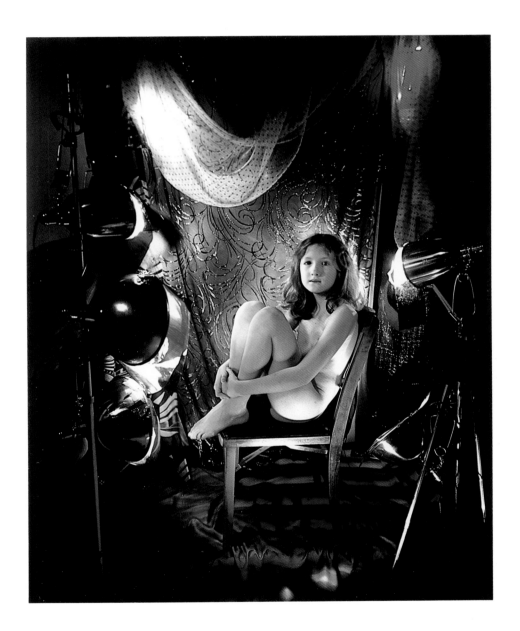

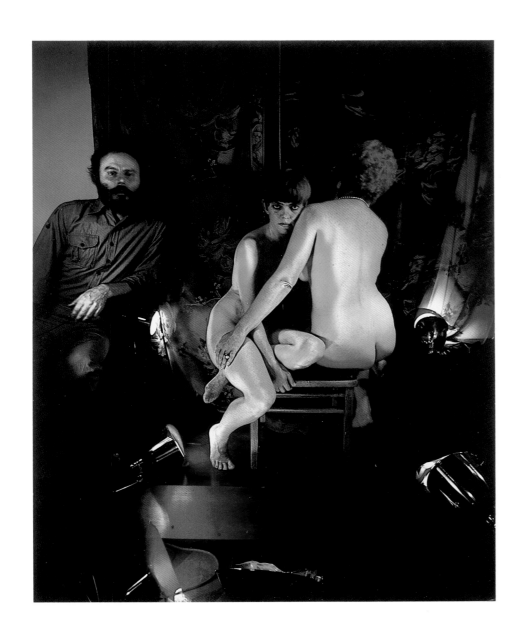

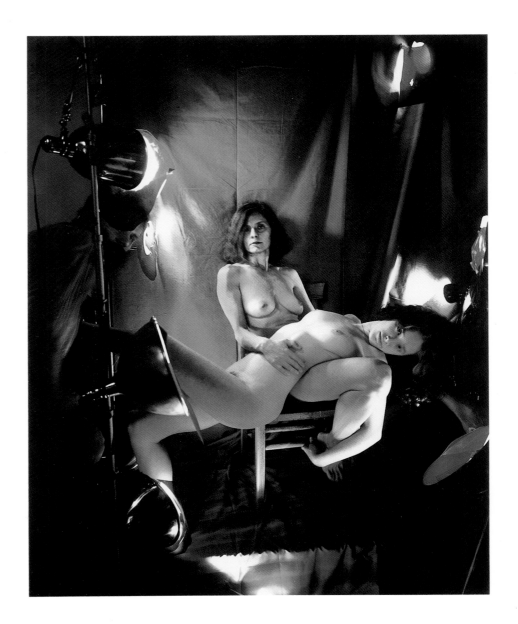

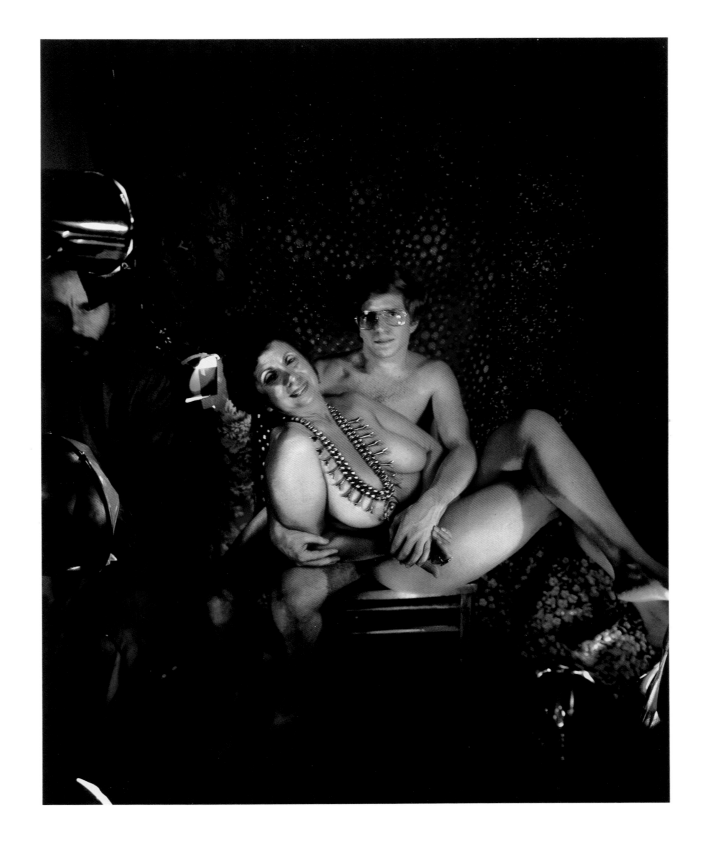

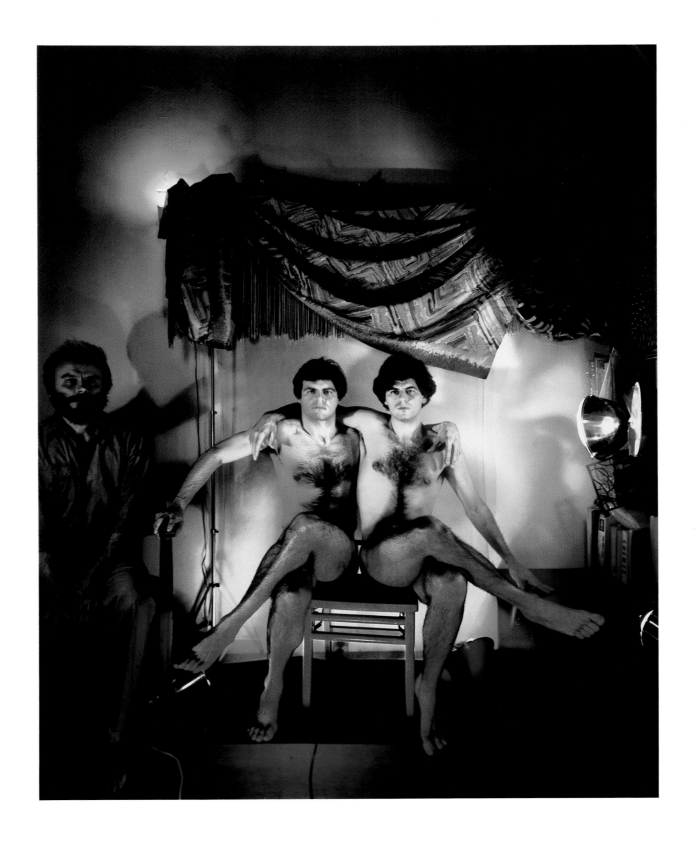

113

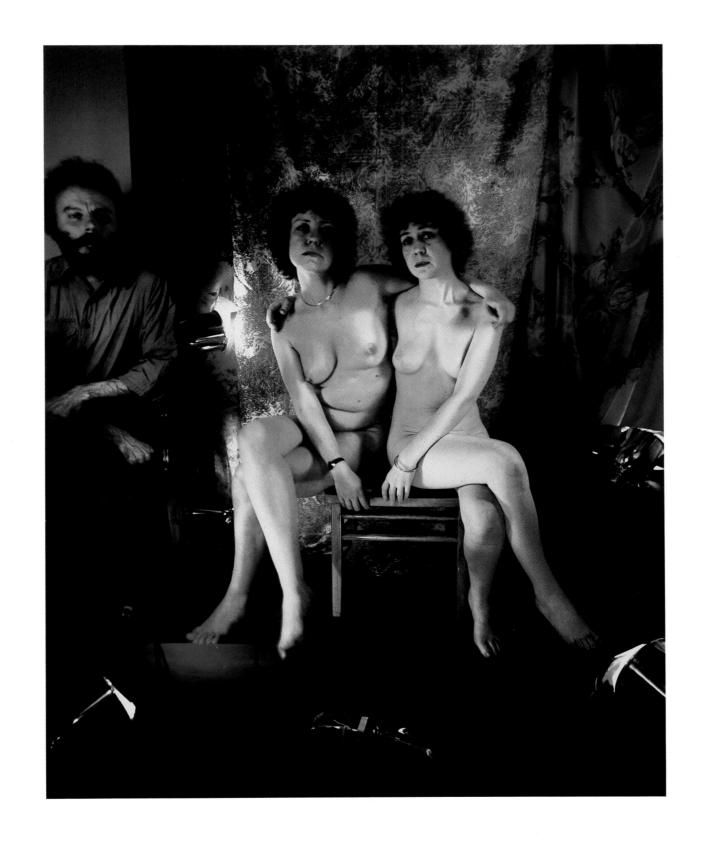

20 x 24 Sittings

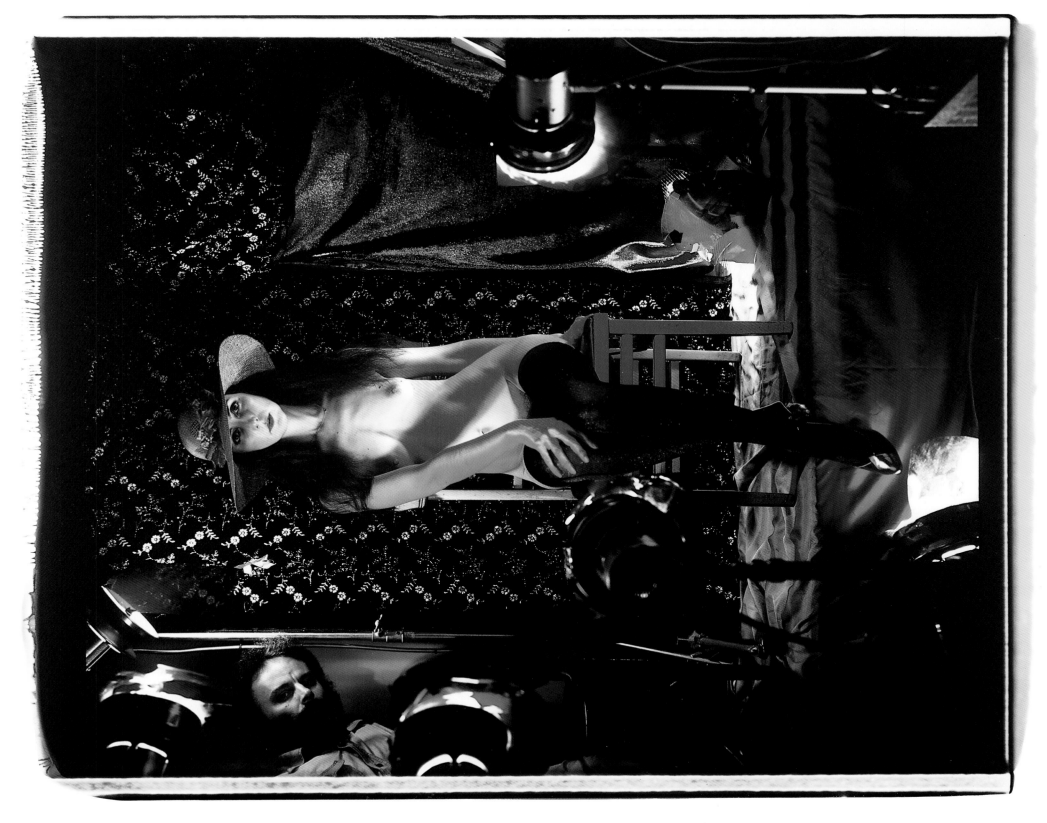

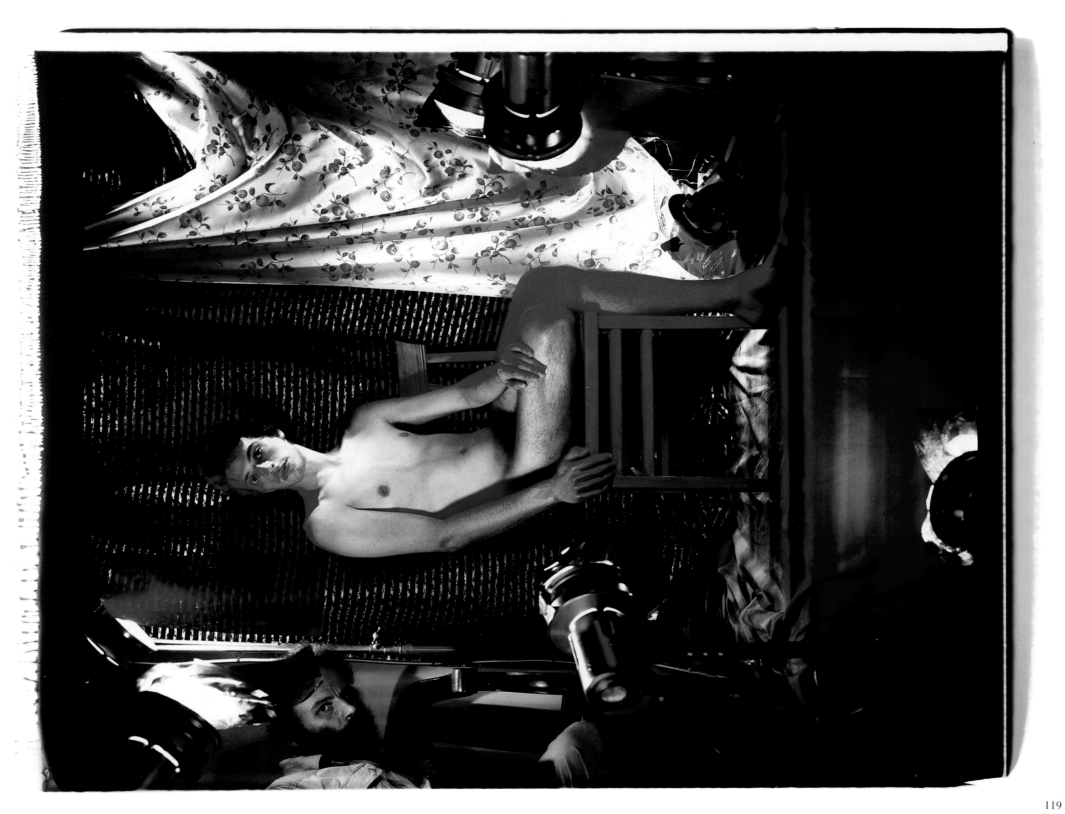

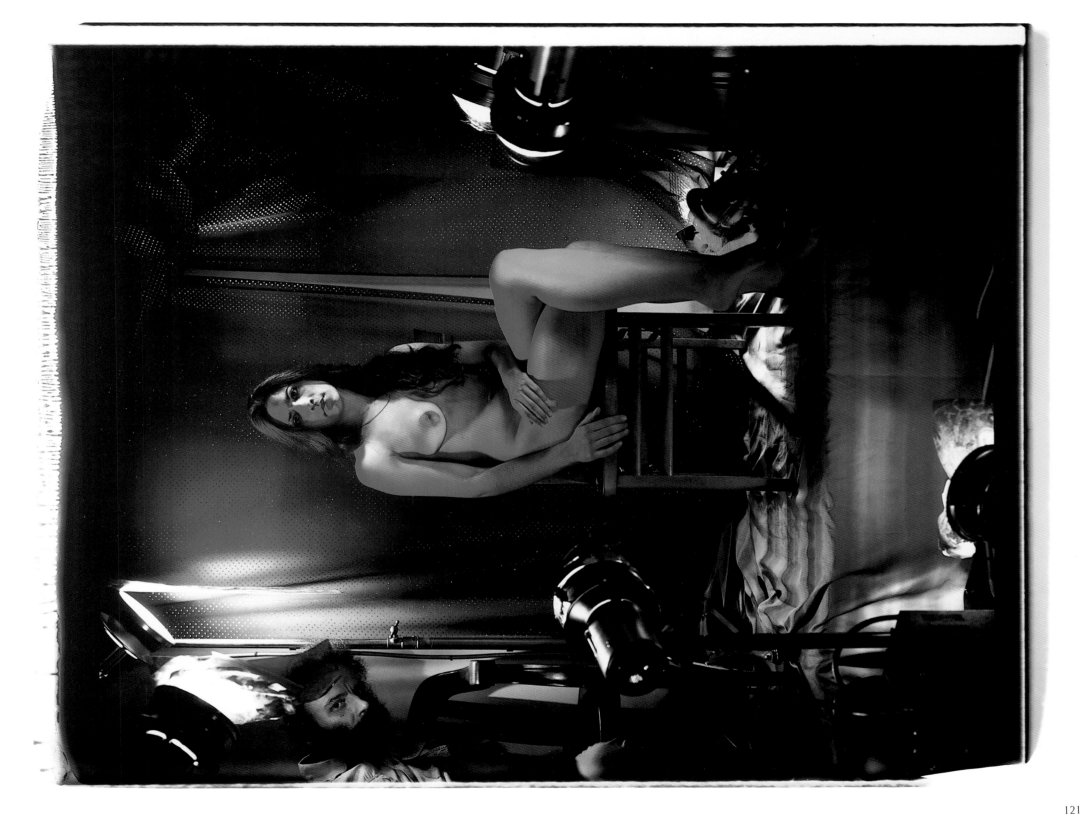

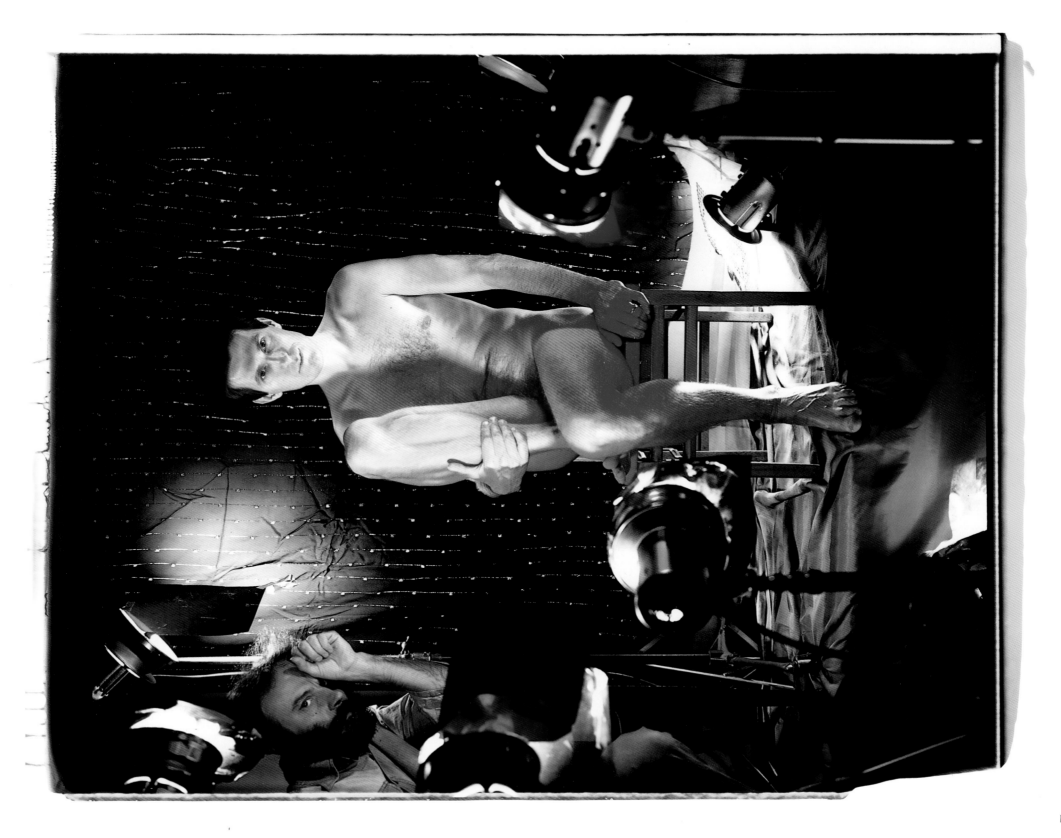

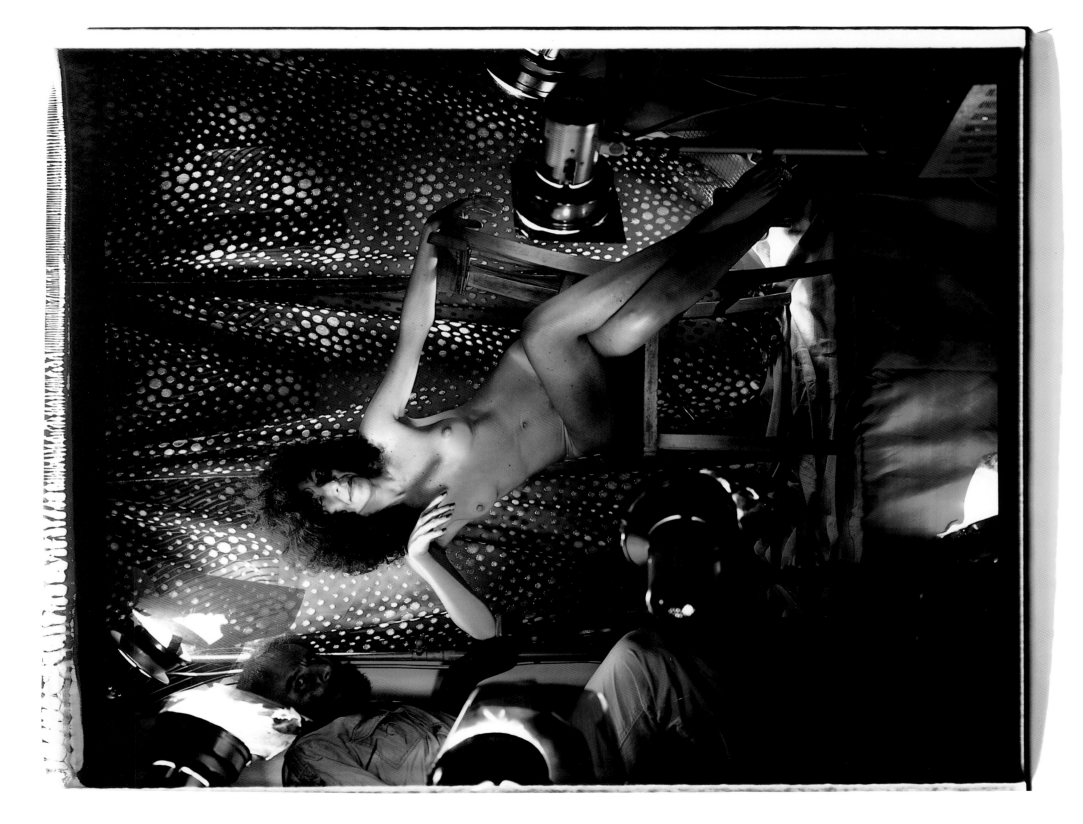

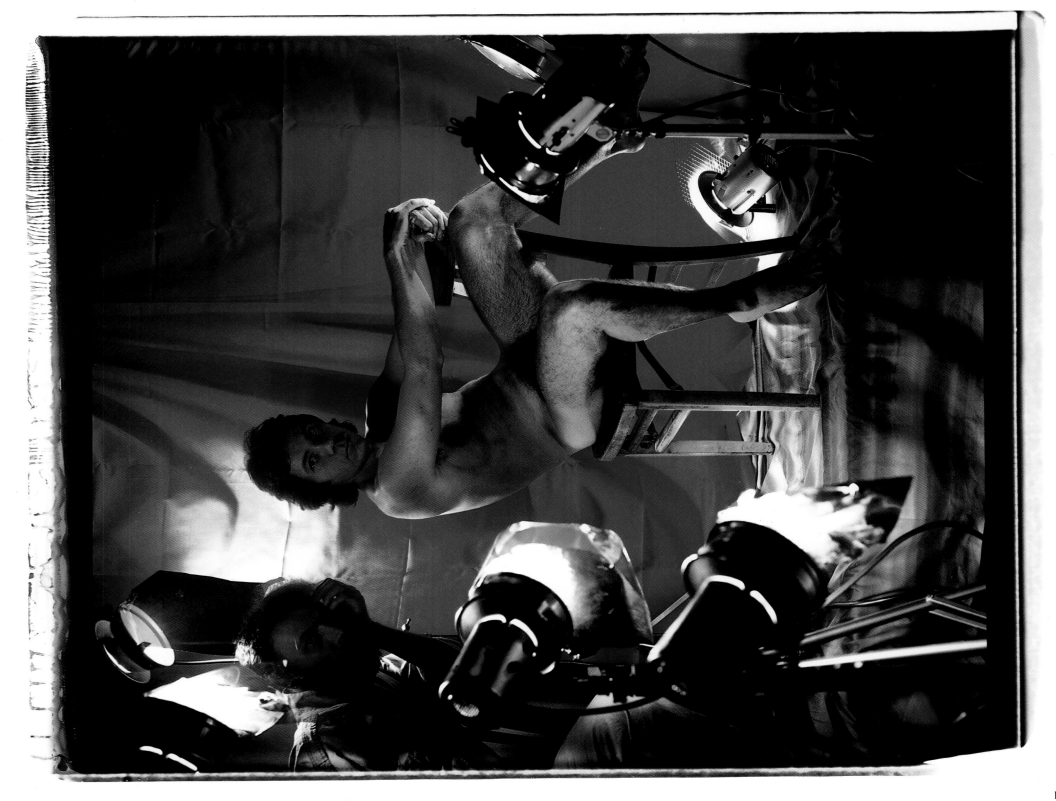

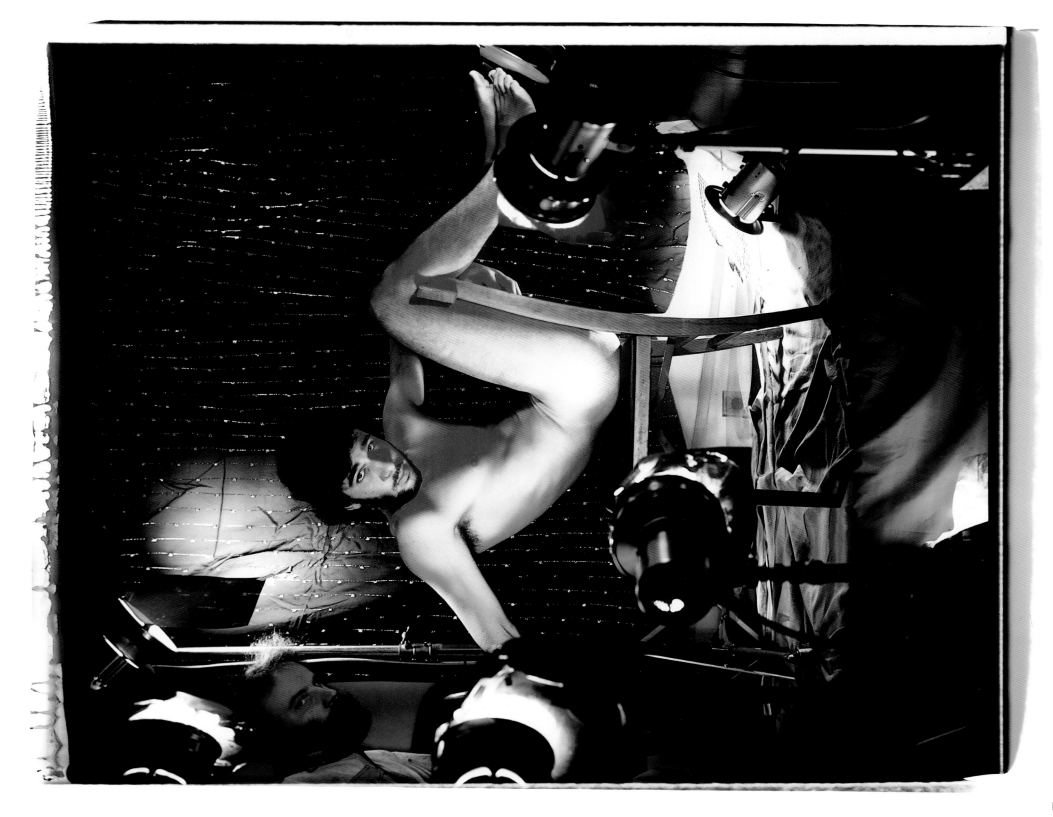

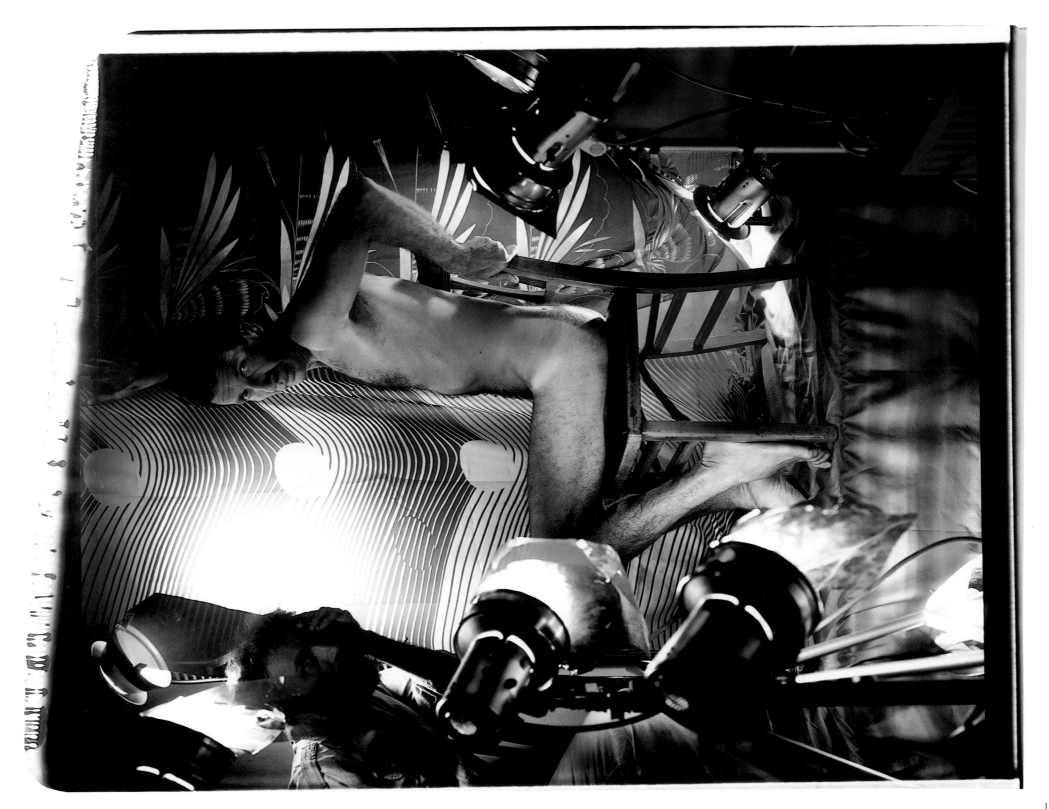

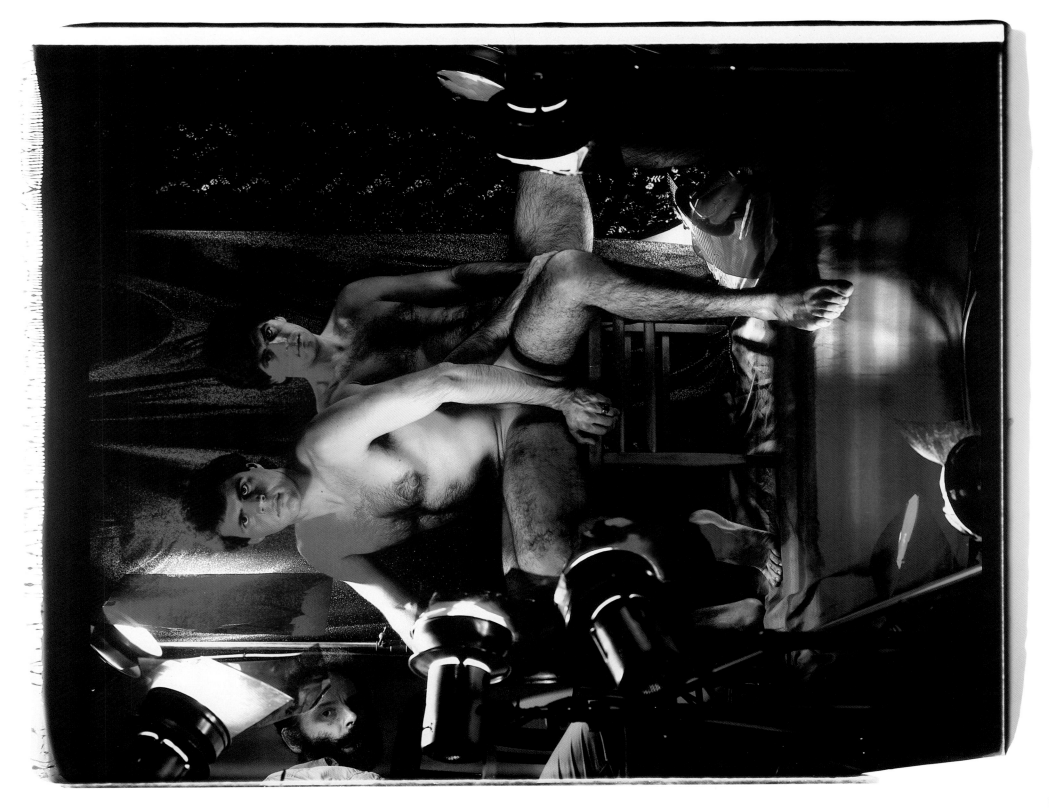

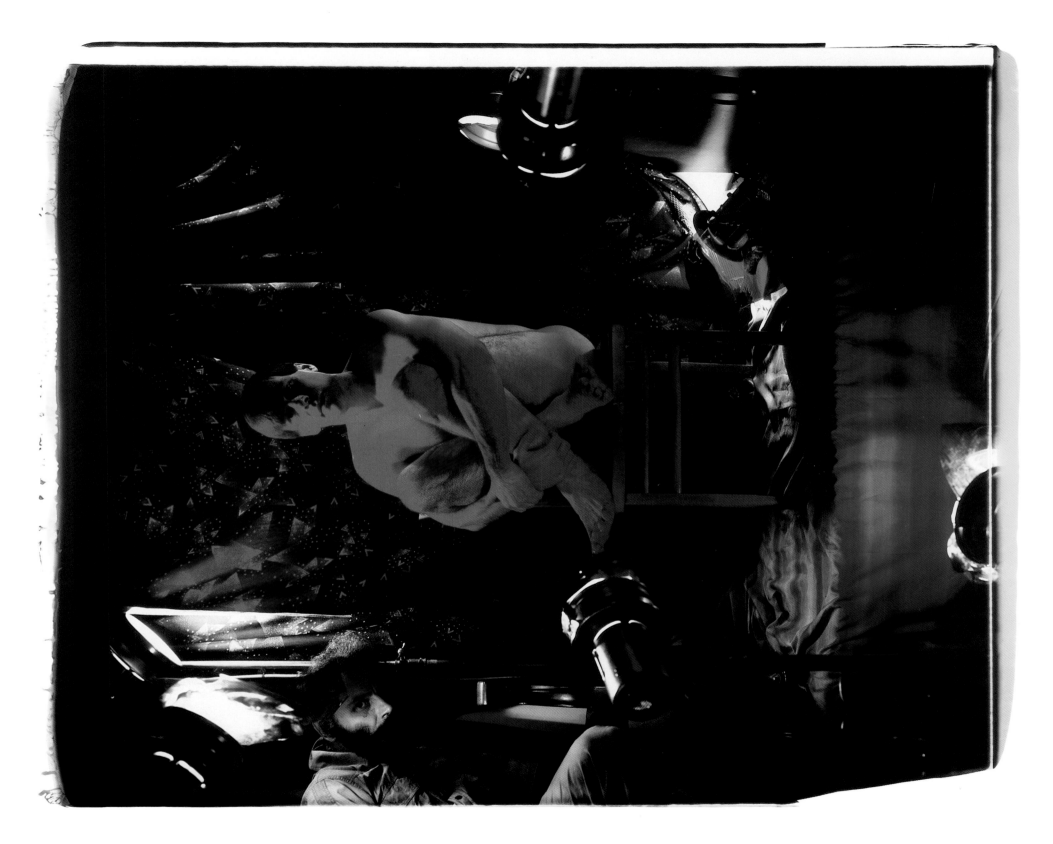

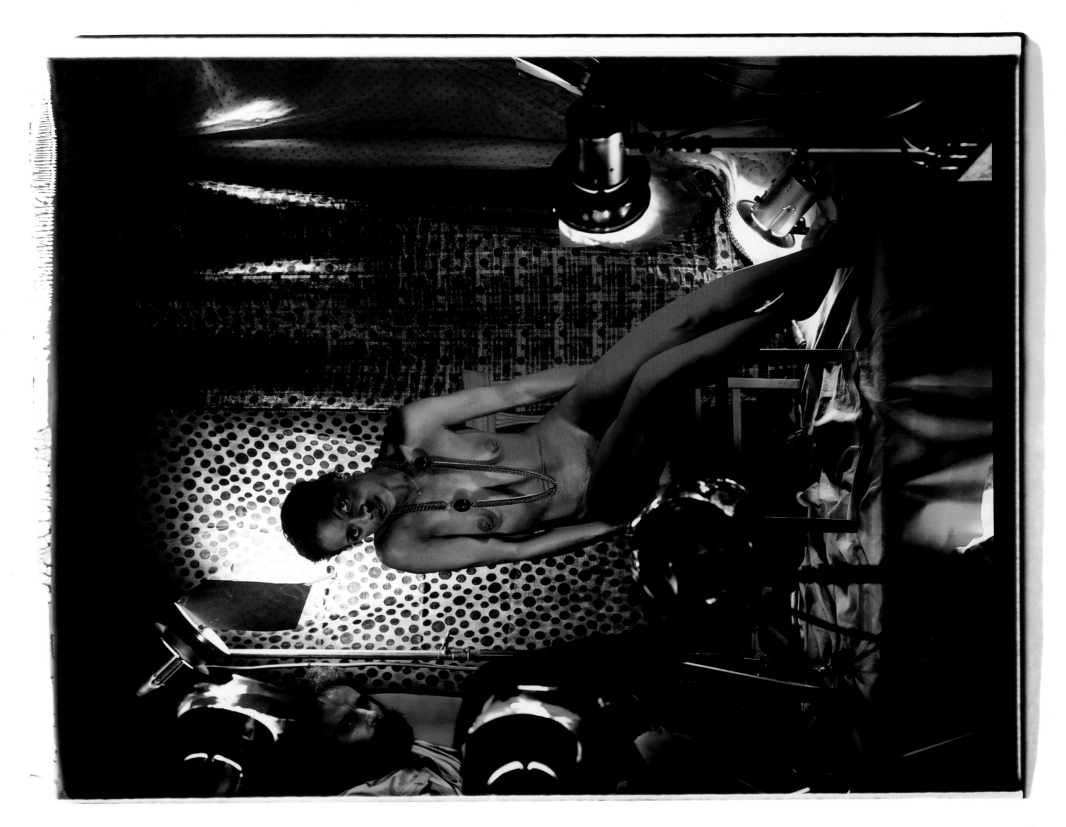

# Ultra-Large

Samaras's art is didactic. It warns us against confusing both creativity and immortality, the artist's ancient and legitimate desire, with unattainable godhead. No contemporary artist acknowledges his susceptibility to this confusion as Samaras does, or is so frank about the isolation and sadness that attend it. And nowhere in Samaras's work is the futility of self-apotheosis expressed so clearly as in the Ultra-Large photographs of 1983 made with the Polaroid room-size camera, which was invented for copying large paintings at actual size and, like all Polaroid cameras and materials, was later made available to artists.

Samaras comes to us full blown out of history. Standing indoors in his winter coat, he quotes the men and women who, in the bare studio of Félix Nadar, the great Parisian portrait photographer of the 1850s, defied convention and posed in their outdoor garments: the illustrator Gustave Doré in a long checkered wool scarf; the composer Gioacchino Rossini in a luxuriously full fur-collared overcoat; the poet Charles Baudelaire, our first philosopher of dandyism, in his outrageously oversize greatcoat. Also, with his coat draped over his shoulders like an opera cape, his hands held in front of him as if he were holding a top hat, scarf, and gloves, Samaras is a figure out of fable and social comedy: the gentleman watching a theatrical performance from the wings, his heart set on some member of the cast. His sinister affectations recall Svengali. How tenacious, Samaras's adolescent image of the *artiste-maudit*!

To the Samaras governed by wish the huge picture represents a means to turn himself at last into a monument. But his rigorous intelligence can't be deceived by so simpleminded a conceit. (This is the artist who interviews himself and so at once indulges and mocks his nonsense.) In the Ultra-Large standing portrait everything is slightly off and awkward.

The gaze he returns seems aware of our summing him up like this: the gaze of one who has been found out.

We are struck by his withdrawn and tender fear. Denied the glamour, distance, and preciousness that he had as a miniature, he is most exposed; in clothes remarkable for their plainness, he is most naked. Has someone within the bundle of selves described by the works—Trilby or Svengali—lost his trust or nerve? Nowhere has Lucas appeared so needy or so frail.

Maybe the camera is to blame. Its clarity and the enormous expanse of surface together magnify every lapse of attention, every breakdown of thought, every flaw in the conception, every blindness and affectation. It gives you no refuge. Samaras, who has pondered the problems of the photograph's surface with the best of them, had to have known this.

His response is heroic. Across a surface that is at last as large as painting's, he asks how the camera might accomplish painterly effects of color spread over large surfaces, and of contours blurred and softened by out-of-focus rendering, without sacrificing either the camera's virtuosic draftsmanship—to reconcile Venice and Florence—or its delineation of character. True, the strong drawing is full of pleasure (consider the forest of light stands and shielded cable, or the gorgeous descent of the sleeves, the beautiful lops of empty cuffs, echoes of Nadar again). But bravura and surprise ride above these solid structural elements: The colors succeed each other across his face in blithe disregard for realism of modeling or for the picture's linear structure. The colored gels melt and swell toward fulfillment. The study of darkness. In color the surface takes on qualities belonging neither to the objects nor to the photographic paper. Samaras's hair seems to burst into solid light, and everything from skin to stitching is transfigured.

Or is it camouflaged? For Samaras's affected elegance crumbles within the exaggerated clear-sightedness and sanity of the camera's scrutiny of character and exposure of desire. Its description gives us the coat for what it is, an ordinary leather coat with a fur collar, nondescript and hungering. Portrayed here is not attainment but longing, and the humanity of the conception and of its failure.

The other two pictures, a hand and a face, seem efforts to achieve in fragment what was denied the whole figure. The hand grasps and strains almost to the point of enfeeblement. The face writes its sorrow all the larger.

The touch and mood of these giant dark works meant to be so stern and imposing are rather powdery, and sweet, and melancholy.

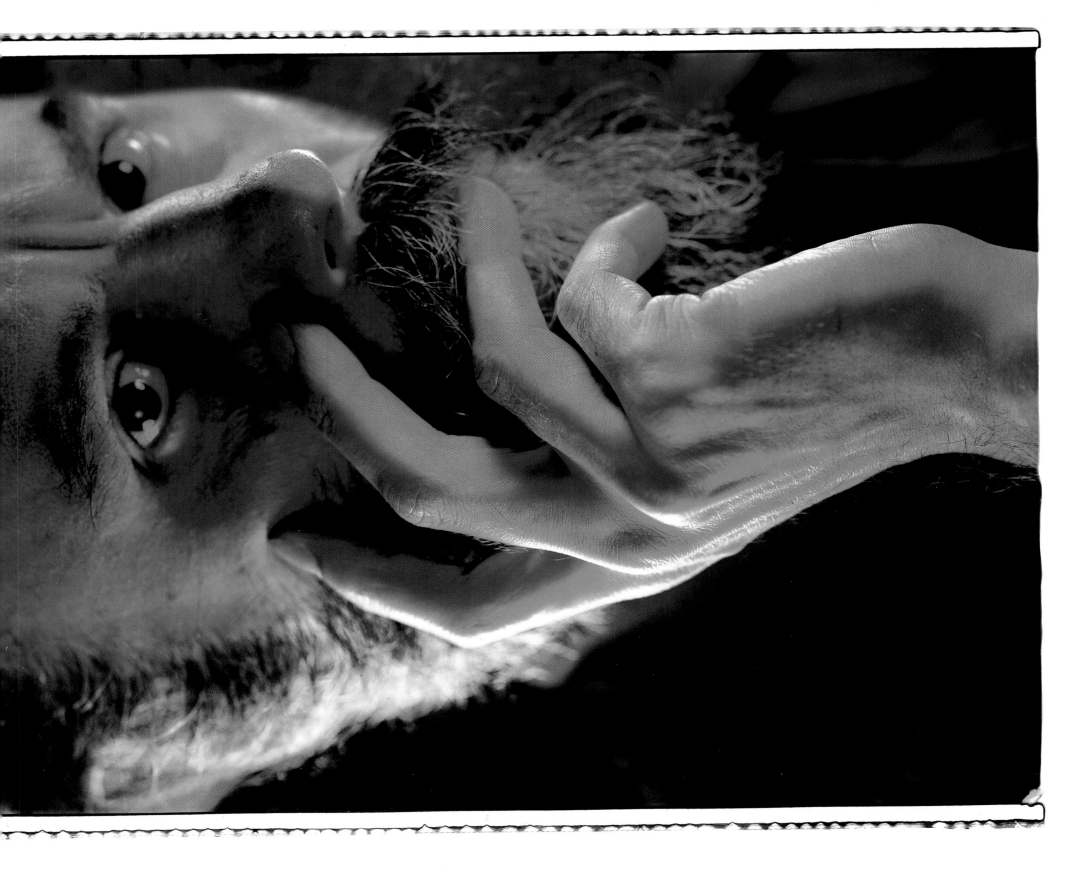

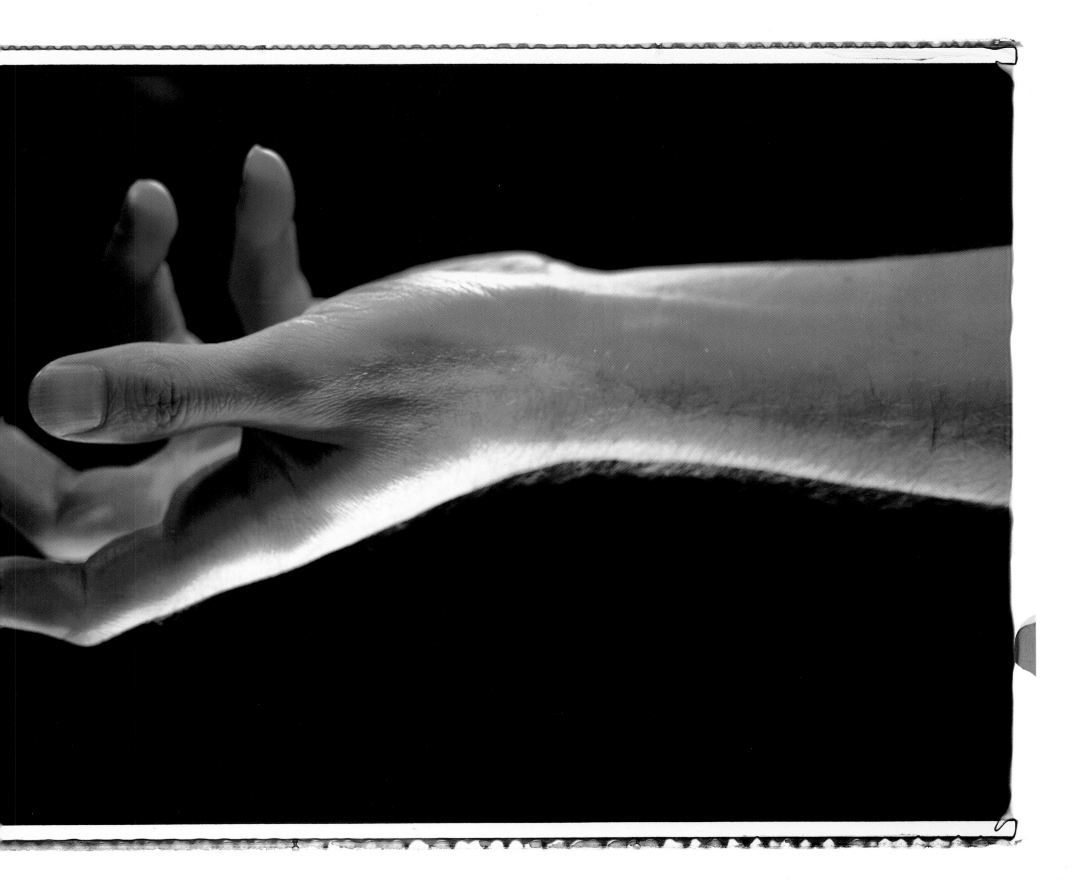

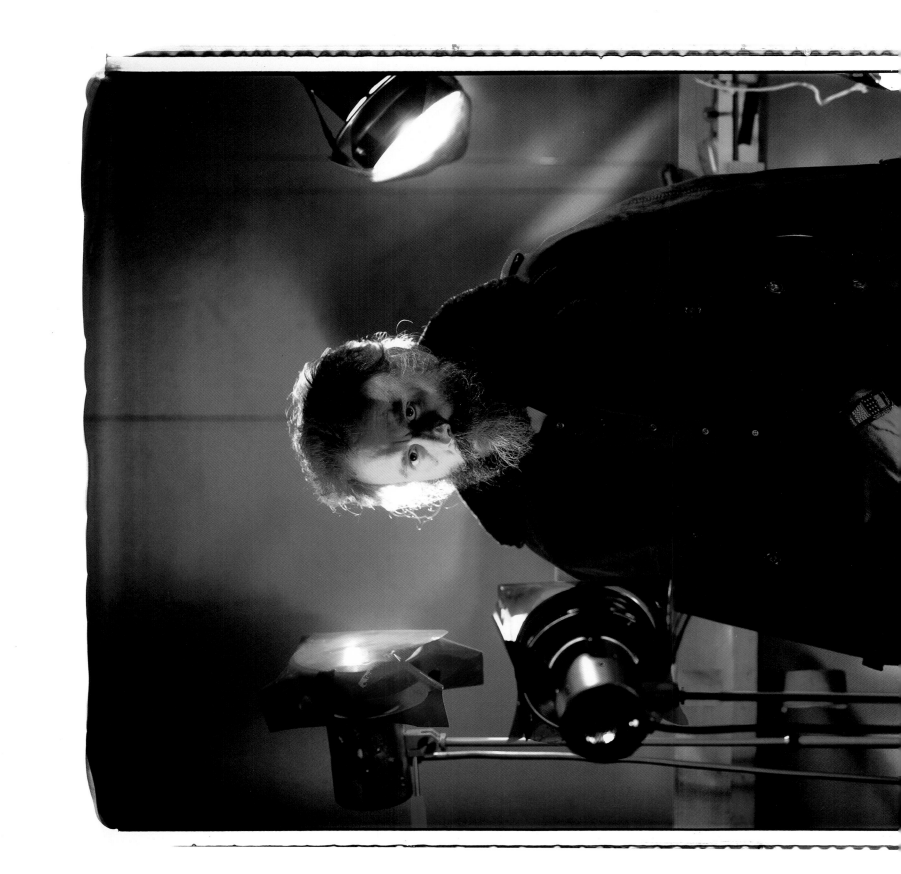

# Panoramas

Two years passed before Samaras photographed again. He began a series of oil paintings (later abandoned) and exhibited a set of small grotesque bronzes. More materials and rejected works accumulated in the apartment. Samaras's hair turned grayer, his beard got longer—at once dandyish and patriarchal—and his face broadened a little. Friends died, and friendships of many years ended in quarrels. "More and more," he said, "I feel myself in pieces; it takes longer and longer in the apartment to feel I've put myself together." To the hero the apartment had proved porous, its refuge flimsy. The sitters, although witnesses to Samaras's external existence, were also invaders who appropriated his space, detached it from his person, and crowded him to its edges.

" . . . when another person comes in, sits down, uses that glass, makes this or that comment, moves that object, changes his facial expressions, my apartment dissolves. It loses its intricacy, its naturalness, its physical extension, its precision. The presence of my visitor infiltrates everywhere like . . . an exhibitionist. . . . When he leaves . . . I have to disperse his independence. . . ."[37]

In the photographs that began around Christmas of 1982 and are still in progress, Samaras withdraws into his place and reclaims its intricacy, extension, precision, and mythical autonomy.

The artist also withdraws from his earlier strategies. He no longer takes his genres one at a time to come to terms with each before moving on to the next. Instead he folds portrait, still life, nude, and self-portrait into the same project and moves fluidly among them, expressing a mastery of craft that transcends genre and discovers meaning not in genre or in subject but in style. He renounces the orthodox, "stripped-down essential camera seeing,"[38] in which he had proved himself in Sittings, and converts the photographic print to a material again; abandoning Sittings' historical, documentary mode and novelistic thrust, he turns toward fantasy.

His means are at once the simplest, most mechanical, of his photographic career and the most disruptive in relation to the print. Samaras photographs each face, body, or still life several times, moving the camera left or right, up or down, anywhere from millimeters to several centimeters, between each exposure. He cuts each print into narrow strips —arbitrarily determined by the 2.22-centimeter width of his steel ruler. The strips are laid side by side to form the new, extended, hybrid image, part mosaic, grid, and photograph.

Samaras does not pledge himself to every strip and thus leaves himself free to invent new forms, like a head whose several eyes and noses collapse on each other beneath a brow that climbs upward like a column. Nor does he align the outer edges of the strips but breaks the linearity of the photographic frame, creating at its borders decorative embellishments, castellations, tiers. Shifts within the image create distortions: a flower warps as if seen in a fun-house mirror; a table swells like a gentle sea.

Common objects and human parts are multiplied and expanded to two or three times their normal length. A hip stretches out and is proposed in an elongation Ingres might have considered; a thigh descends to a knee like a formal staircase to a lawn. We have the dual sensation of a scene reflected in a multi-faceted mirror and a world opening sometimes like an accordion, sometimes like a fan.

The elongated fragmented objects surrounding the human figure lose their specific shapes and identities as crockery, figurines, house plants, and flowers and disintegrate into repeated spots of intense color and varied shape. Strings of beads, the tiled floor, a radiator, solid or patterned fabrics—paisleys, plaids, checkerboards, stripes—come apart and re-form themselves as swirls of color, line, and shape. From three to about fifteen times longer than the photographs from which they came, these pictures approximate the physical presence, abstraction, and decorative intensity of painting.

But they are not abstract. The space of the kitchen, although extended from side to side, is neither flattened nor layered but deep and perspectival: The illusion of deep space is naturalistic. Each strip is dense with information, its meticulous, transparent surface rich in descriptive photographic detail. The stretches of abstract color and line attract us the same way pure pigment draws us to the painterly surface of a Turner or a Pollock, yet disclose neither brushstrokes nor material but images of crockery, figurines, and skin.

Samaras has again divided our responses. We absorb these fantastic views in an instant. But their intricacy draws us in, and they unfold slowly, piece by piece, like slowly opening scrolls. We follow the figure and the apartment across the picture detail by detail, the way we progress slowly across the alpine peaks, or the domes and minarets of Istanbul, in

nineteenth-century panoramic photographs, themselves pieced together out of several prints, and the form to which Samaras's new work refers.

In nineteenth-century panoramas, landscapes that in life surrounded the camera were transformed into long, false horizontal prospects, spatial fantasies. Samaras's panoramas are psychological fantasies, yearnings extended into space. They transform the apartment from the public artwork of Sittings into an ancient exotic capital, a sublime vista, a cultural and natural monument. Human figures other than Samaras are displayed on the table, prowling, writhing on their backs, like specimens of mutant species. The image of Samaras himself flows across the panoramas slowly, like a cortege; he takes possession of his apartment like a pageant figure taking possession of the stage, a god claiming his mythological realm.

In some photographs he leaps in solemn yet frightened ecstasy, grasping the camera's cable release. In others he sits at the table in gloomy majesty, rising above the horizon like a colossus. There he brandishes a pair of shears. Cable release and scissors are the instruments of his ambiguously creative and destructive power. Should he lose his hold on the cable release, his fiction could be stillborn. Should the anger in his face gather to a storm, the scissors could undo his world as easily as they helped bring it into being. The monumental space and godlike hero of Samaras's wish-fulfillment panoramas are fragile, pieced together, held in place by tape.

There is pathos here—Samaras's inability to imagine future episodes for his fiction and an ultimate psychological harmony for his hero, as a novelist can. By the very nature of his medium he is time-bound. He can only await his future and work from there.

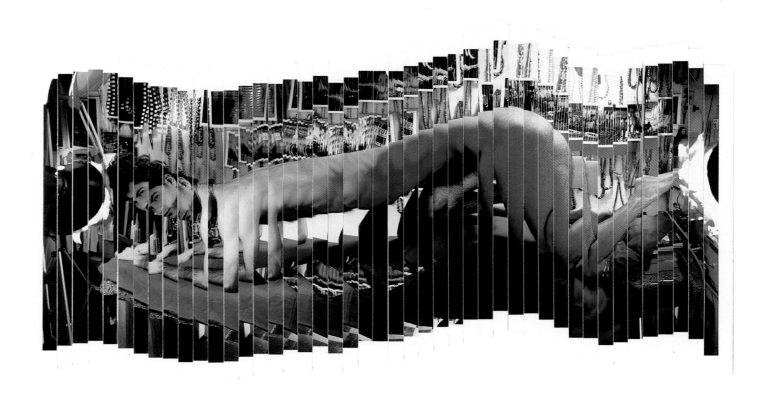

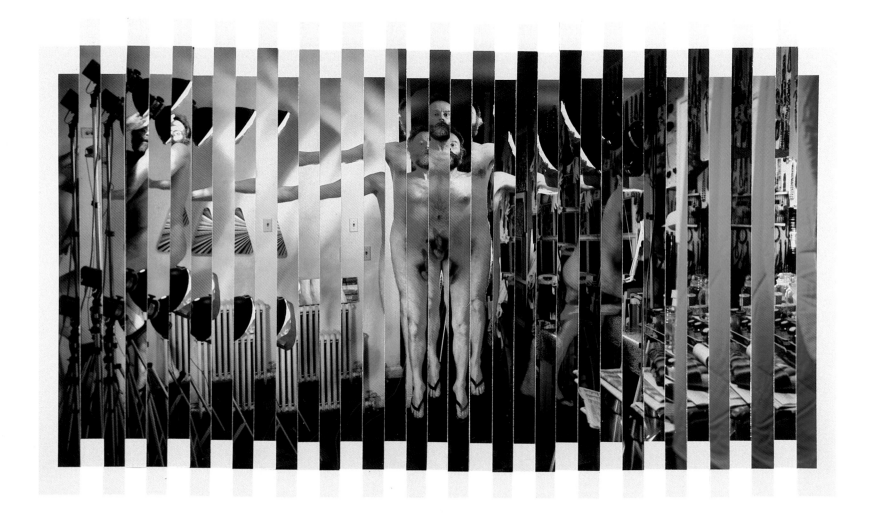

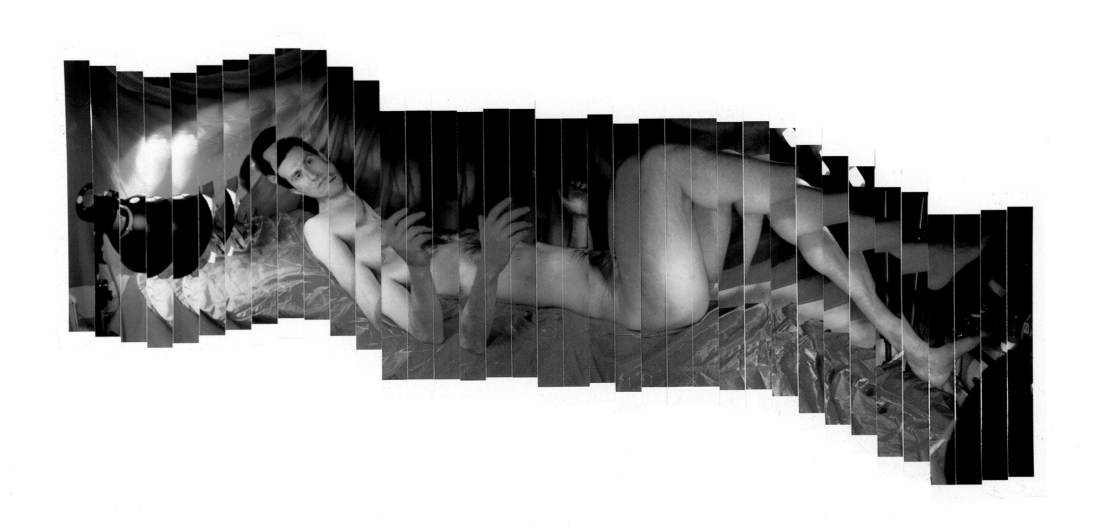

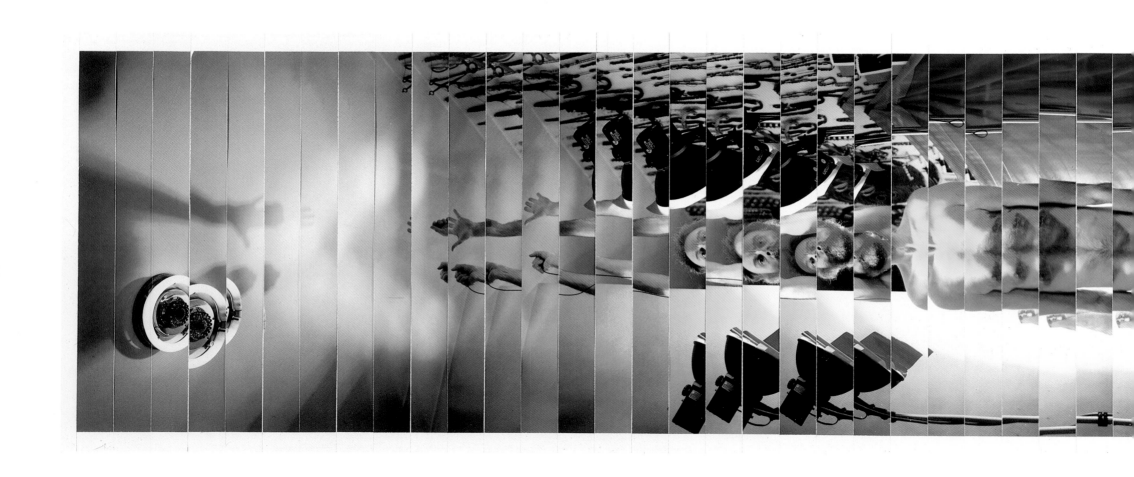

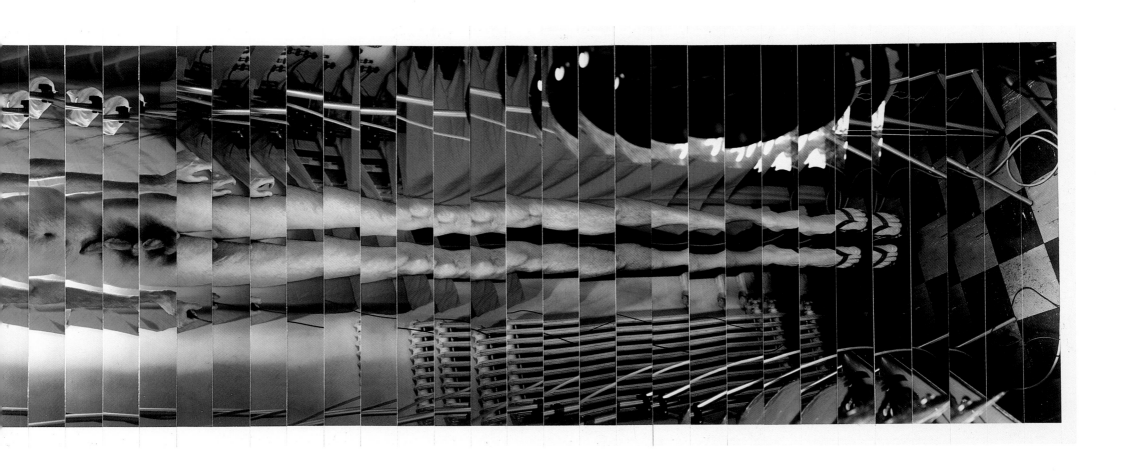

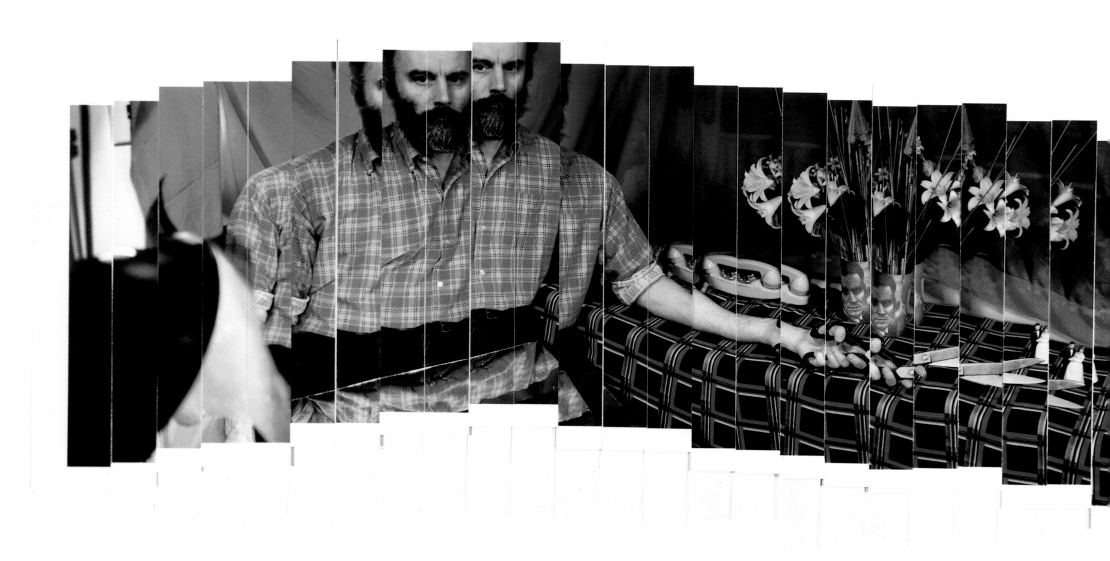

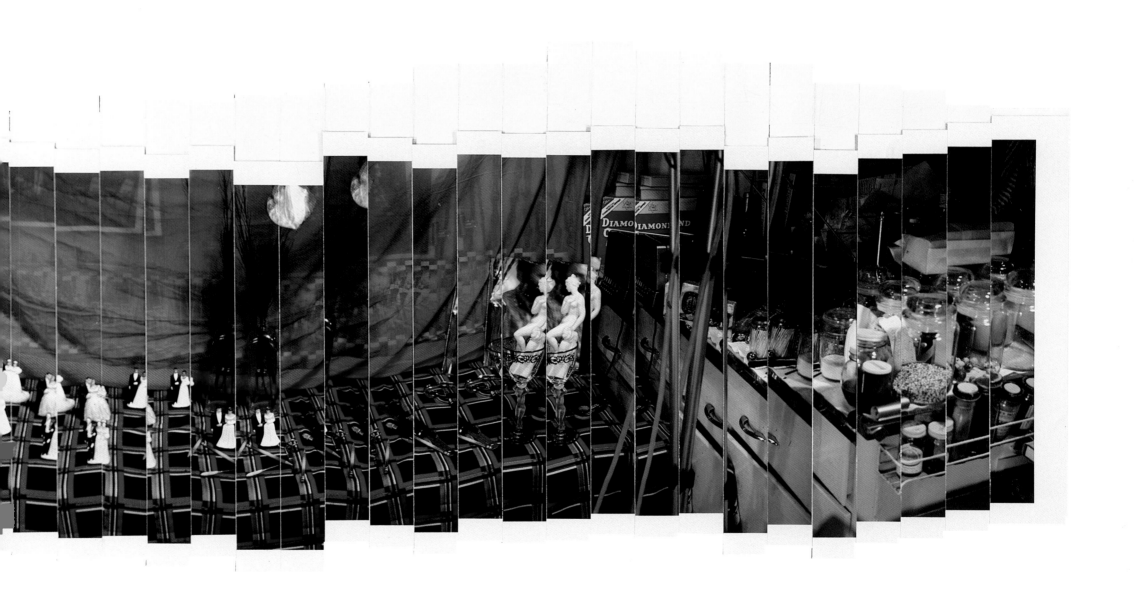

157

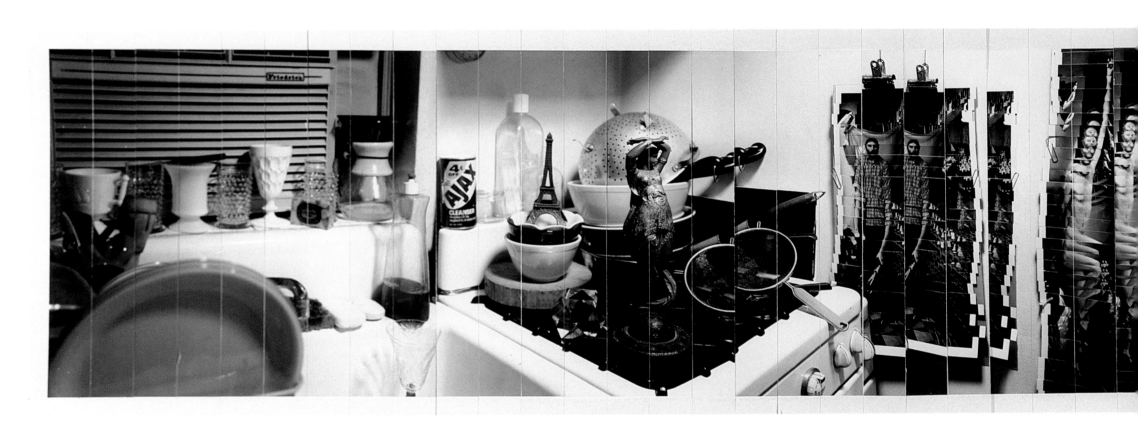

159

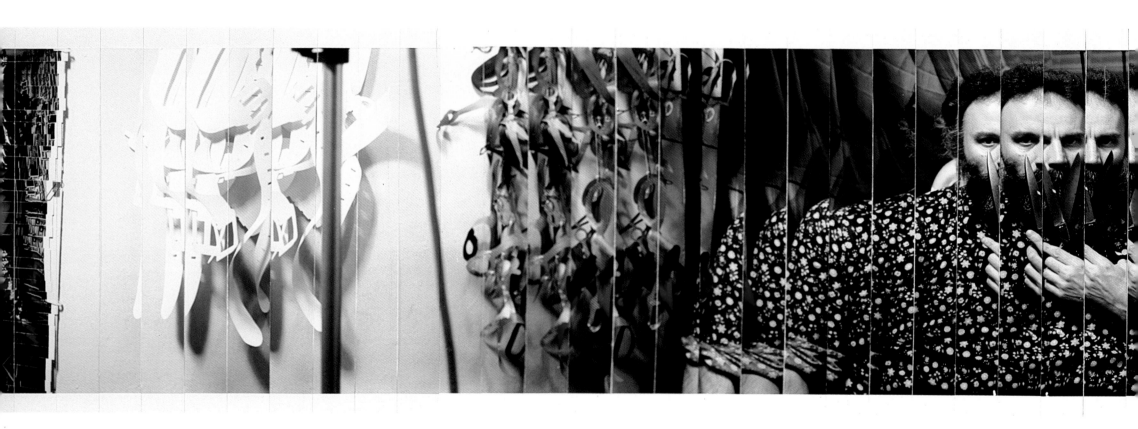

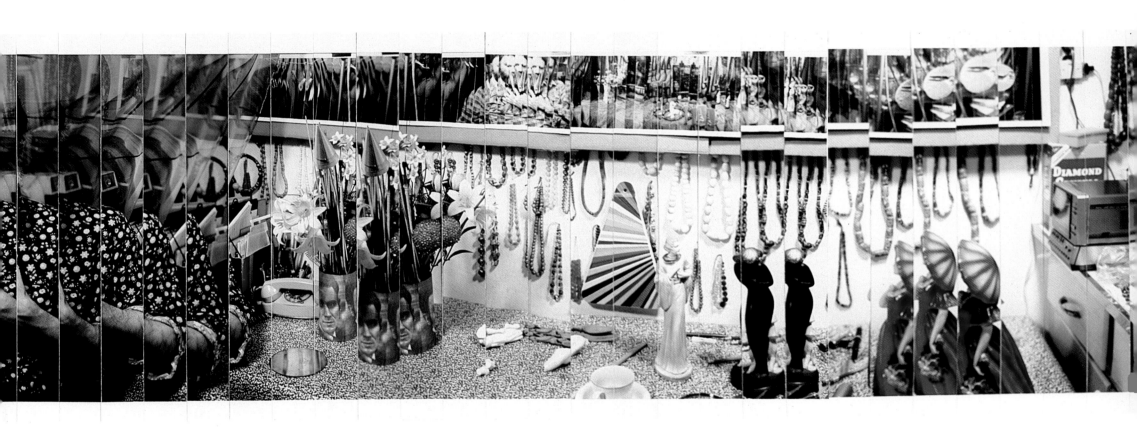

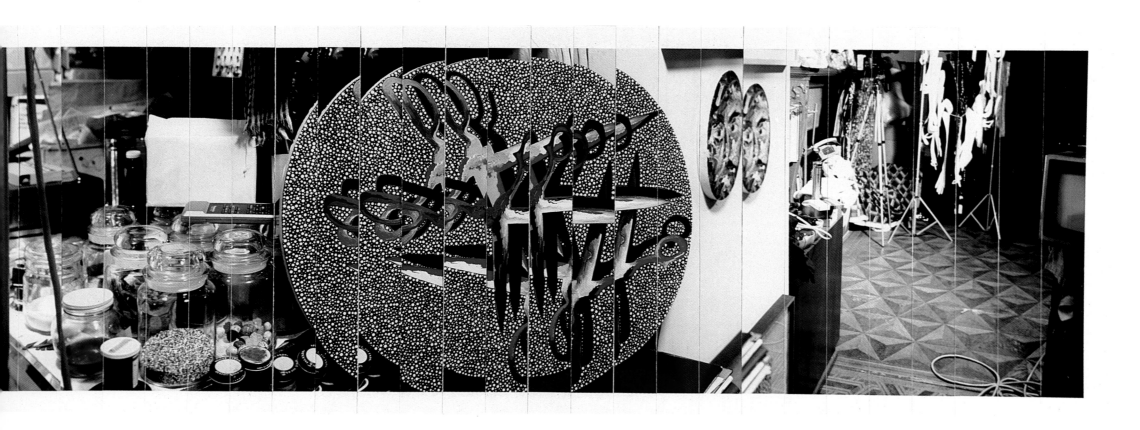

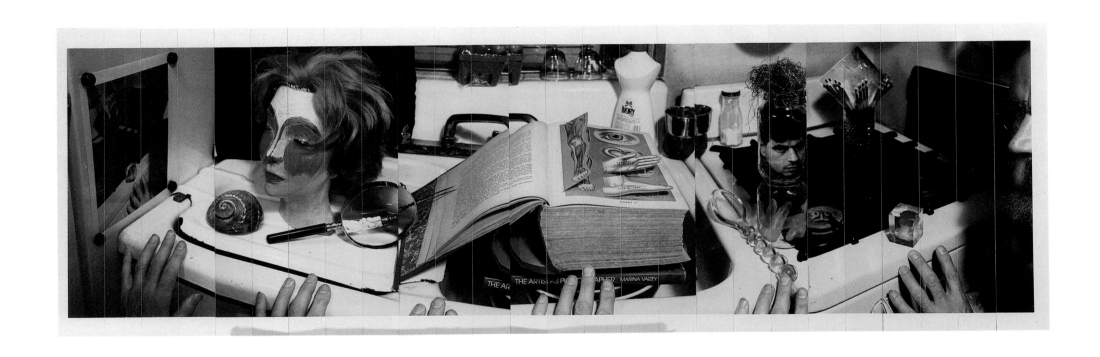

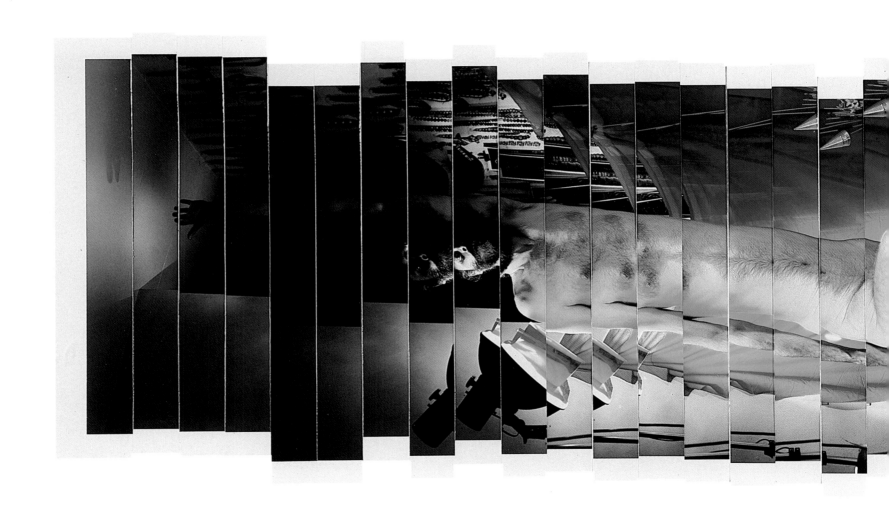

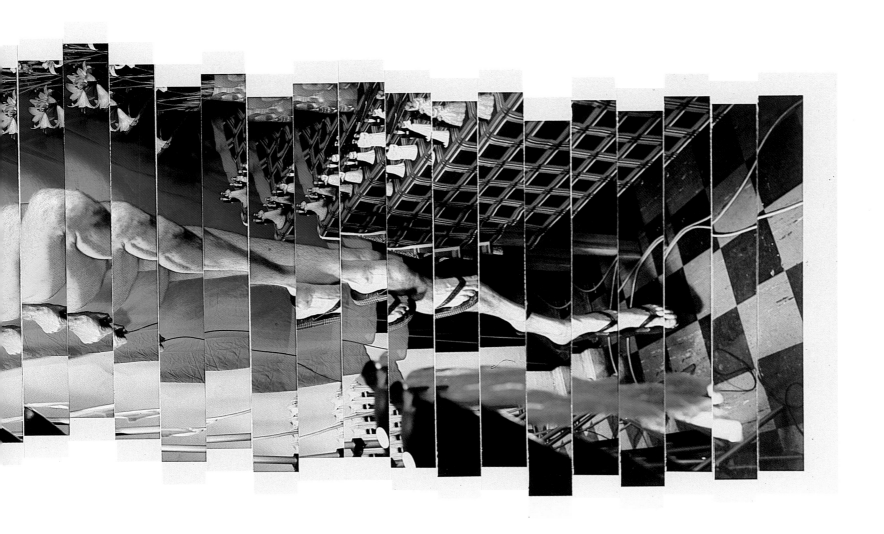

Heads

To concentrate for so long on such autobiographical work is to risk an identification with one's subject that exceeds in closeness what is useful or healthy for the writer. You imagine intimate knowledge of the subject, and hence of the artist, when all you really know is surface. Believing yourself to be part of the artist's psyche and sensibility as he brings the work into being, you believe that it is the artistic process, not the art, that you behold and must describe.

This is true especially when the work is on the one hand as literal as Samaras's and on the other as blatantly allegorical as these six pictures from 1986: portrait heads of friends, each sitter holding up a small jar with another portrait of himself or herself within it. The pictures in the jars are distorted and made grotesque by the curve of the paper and by the refraction of and reflections on the glass. Although in these pictures the allegory of self and image is complex, the portraits are as swift, pointed, and summary as political cartoons; they express and seem to exhaust the allegory before we can even begin to put it into words: an enviable quickness. Their understanding of how visual imagery can seem to address language while actually speeding right through it, leaving it excited and useless, is, as always with Samaras, dazzling. Yet the portraits are dry and flat. They have Samaras's power but lack his muscle. We feel a lassitude, a boredom, a straining, a desperation.

Perhaps it is only our romantic myth of the artist that makes us uneasy when an artist flags. Perhaps Samaras has prepared our discomfort by taking that myth as his theme, himself as the artist-hero. Or perhaps we see his pictures as literary before we see their draftsmanship and color. We are forgetting that these portraits are the first in which Samaras has not included himself.

There is sorrow here. It has to do with the feeling that at last the well of self has run dry and that the artist, from dwelling too long there, cannot enagage when he looks elsewhere. These, at any rate, are words that come to fill the silence left by pictures for which explication is pointless and whose visual excellences please but do not surprise—words that I have spent a page trying to avoid. To which I would add something about Samaras's courage in making public what strikes me as a lesson intended only for himself.

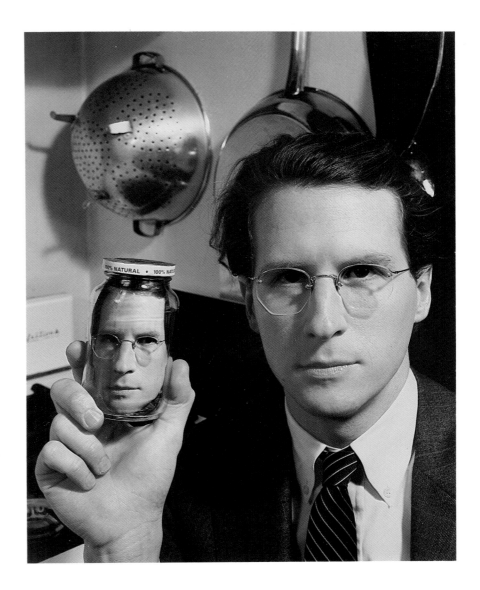

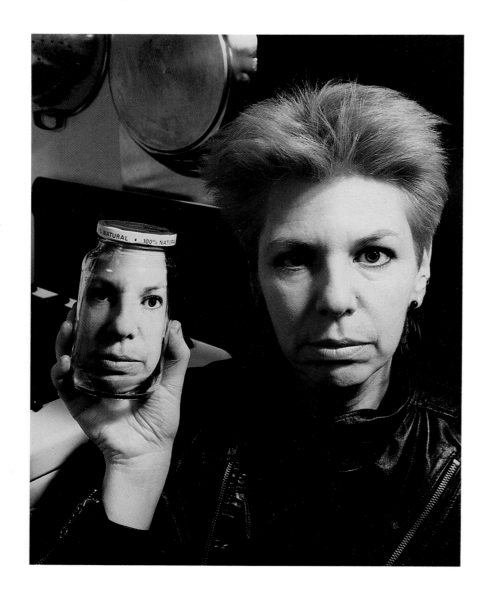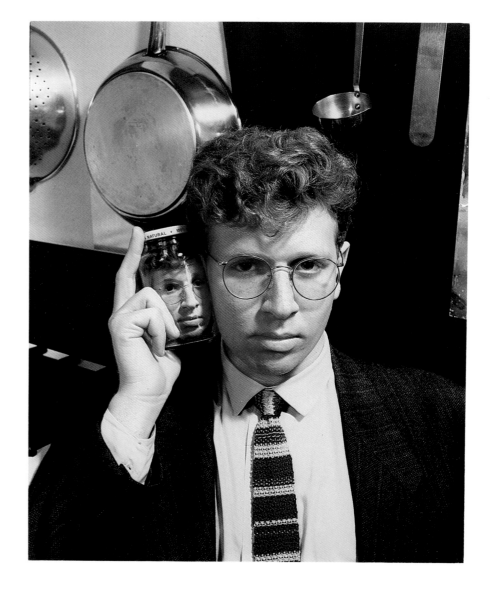

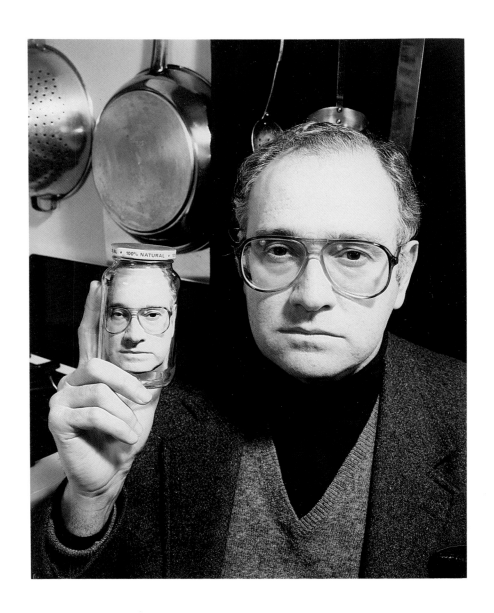 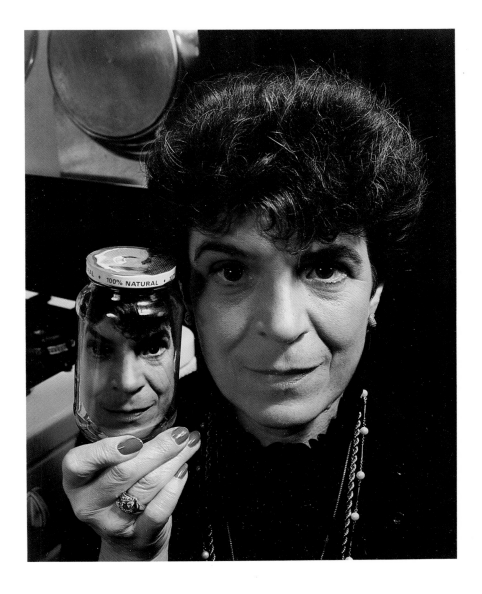

# Adjustment

The futility that colored the Ultra-Large pictures has returned, tempered by world-weariness, and dominant. Consider only the self-characterization. Here is contemplation, not action; and instead of the younger man's athletic exhilaration, his delight in sheer bodily inventiveness, the pleasure he took in his ordinary nakedness and even in panic and desperation—instead of his forthcomingness, enervation. (Never has Samaras placed the figure in so tentative a relationship to the picture plane.) We balk at calling the hero of AutoPolaroids father to this inward-slumping man in a wrinkled flannel shirt even though the delicate pinks and charcoal grays of his plaid shirt are a softening, not an abandonment, of Samaras's earlier taste in clothes. As for the now overfamiliar kitchen and its objects—the figurines, scissors, and so on—their symbolism is obvious, their tawdriness clear, and sad, and accepted, their beauty simply stated.

This is also the first work in which the artist forgoes his inventiveness. Instead of many variations implying many more, there is only one picture. And Samaras shrugs off his once vaunted dexterity. All his cutting and reassembling here have transformed the figure only slightly: the left sleeve has a ghostly echo.

The seams here inscribe an irregular grid across the image. It reminds us of the grids that Renaissance artists laid over drawing paper and canvas before they translated the small drawing into the large painting; of a practice, that is, that assured the safe passage of the image from its original conception to the large public performance; and of a vision of continuity between the small and tentative on the one hand and the monumental on the other. But what canvas is this picture the study for?

Could one exist? This question arises whenever Samaras's photographs so clearly invoke painting's physicality, presence, ethos, expansiveness, and finality. I can't think of a contemporary painter whose handling of paint and knowledge of older technique could equal the sheen, density, love of surface, and desire required by the painting proposed by this photograph or by any of Samaras's photographs.

One wants to ask Samaras if he could tolerate obscurity for the few years it would take him to learn to paint just that much better and then to make the richly allegorical paintings that have been implicit in his art from the beginning. To say, "Is it possible that you are the one to revive painting, and have been all the while? It is time to stop reviving it in your head, time to put your hand to it."

In Samaras's exhibition at the Pace Gallery in New York in March 1987 were a number of drawings after earlier photographs. They were not the first. If Adjustment does in fact appear in another medium, it will most likely be a drawing, a sketch—a dream, a conceit. As such it will still contain its longing for Platonic calm, stability, and order to replace the no longer tenable Ovidian energy and striving.

Adjustment indeed.

As always with Samaras, obvious mechanical devices—here the grid made out of seams—encourage us to see his appeals to the ethos of older art as wish. In fact, he manages to make wish as central and crucial to visual art as it is to poetry. If we can write "miraculous" about any aspect of Samaras's achievement, it is here.

The solitary picture with its sad title feels like an envoi.

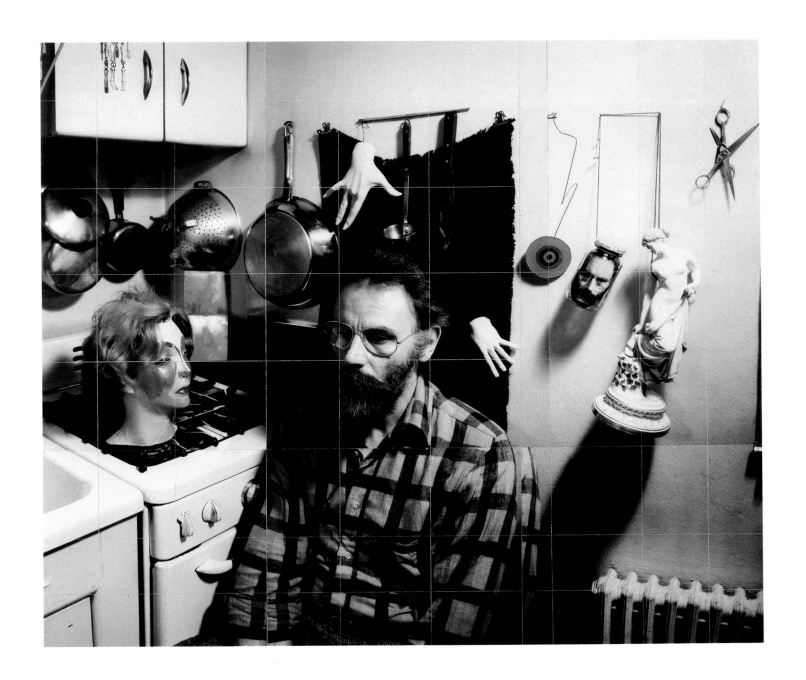

# Notes

1. At the same time, photo-realist painters were appropriating the iconography and imitating the surfaces of documentary photographs, and at the end of the seventies, postmodernist painters began to quote the imagery and style of photographs found in newspapers, fashion magazines, calendars, snapshot albums, and scientific reports.

2. Among the happenings Samaras remembers best are two by Claes Oldenburg in which Samaras approximated the stillness of figures in photographs: In one he wore a tinfoil mask; in the other he moved in slow motion—"It took fifteen minutes to cross the small stage."

3. Kim Levin, *Lucas Samaras* (New York: Harry N. Abrams, 1975), p. 15.

4. Unless otherwise indicated, all statements by Samaras are taken from interviews conducted in February, 1983.

5. John Szarkowski, *The Photographer's Eye* (New York: The Museum of Modern Art, 1980), p. 9.

6. In the catalog of his 1961 "Art of Assemblage" exhibition, William Seitz writes: "[This] catalogue lists the materials incorporated in each work. It suggests the limitless diversity that relates assembled art to the world." *The Art of Assemblage* (New York: The Museum of Modern Art, 1961), p. 81.

7. Tod Papageorge, Introduction to *Garry Winogrand, Public Relations* (New York: The Museum of Modern Art, 1977), p. 13.

8. Ibid., p. 14.

9. Studies of ice, water, rocks, sand, grass, farmland, deserts, machinery, and peeling paint by Americans such as Minor White, Edward Weston, Ansel Adams, Paul Strand, William Garnett, and Aaron Siskind come quickly to mind.

10. Szarkowski, *The Photographer's Eye*, p. 8.

11. "Unlike the contemporary body artist, the residual of whose performance is recorded on film, Samaras's picture is the total work, as was his intention from the beginning. He denies his audience the sharing in the process that is the currency of the conceptualists, as well as the body artists. . . ." Arnold Glimcher, Introduction to *Lucas Samaras: Photo-Transformations* (Long Beach: The Art Galleries, California State University; and New York: E.P. Dutton, 1975), p. 11.

12. Ibid. p. 10.

13. Lucas Samaras, *Samaras Album*, (New York: The Whitney Museum of American Art and Pace Editions, 1971), p. 9.

14. Notes 14 through 31 refer to Samaras, *Samaras Album*: (14) p. 9; (15) p. 51; (16) p. 49; (17) p. 11; (18) pp. 49–50; (19) p. 12; (20) p. 11; (21) p. 9; (22) p. 12; (23) p. 51; (24) p. 9; (25) p. 54; (26) p. 103; (27) p. 55; (28) p. 54; (29) p. 13; (30) p. 11; (31) p. 51.

32. Glimcher, Introduction to *Lucas Samaras: Photo-Transformations*, p. 8.

33. Three years before Samaras began photographing himself, Lawrence Alloway wrote of the assemblages: ". . . Samaras organizes his objects on the basis of cells which we examine one at a time. The subdivisions of each work and the number of loose articles it carries forces us to draw close. Peering is how to see a Samaras . . . [The] scrutiny of successive views and objects involves us in time as well as in space." Lawrence Alloway, *Samaras, Selected Works 1960-1966*, (New York: Pace Gallery, 1966), p. 16.

34. Samaras, *Samaras Album*, p. 14.

35. Brothers and sisters pose as Siamese twins and unknowingly re-enact for Samaras a memory of his aunt's postcards of American freaks, and in all the photographs we can sense Samaras revising old snapshots of his relatives in Greece posing in carnival dress against a photographer's painted backdrop.

36. In a second round of Sittings, done with Polaroid's massive 20 x 24-inch studio camera, the sitters become, by consequence of the larger scale, public, even heroic, figures. They mostly pose erect in the chair, like statues of public men and women in parks and the rotundas of government buildings. They gaze directly, solemnly; their virtues are reserve, concealment.

37. Samaras, *Samaras Album*, p. 14.

38. John Szarkowski, *Mirrors and Windows: American Photography Since 1960* (New York: The Museum of Modern Art, 1978), p. 24.

# Chronology

## ONE-MAN EXHIBITIONS

1955　Rutgers University Department of Art, New Jersey.
1958　Rutgers University Department of Art, New Jersey.
1959　Reuben Gallery, New York.
1961　Green Gallery, New York: *Dinners, Liquid Aluminum Pieces, Pastels and Plasters.*
1962　Sun Gallery, Provincetown, MA: *Pastels.*
1964　Green Gallery, New York: *Bedroom, Boxes, Plastics.*
　　　Dwan Gallery, Los Angeles: *Boxes, Wall Pieces.*
1966　The Pace Gallery, New York: *Mirror Room, Transformations, Boxes, Skull Drawings.*
1968　The Pace Gallery, New York: *Transformations, Mirror Stairway, Cut-Paper Drawings, Pastels, Inks and Acrylic Paintings, "Book."*
1969　Sachs Print Gallery, Museum of Modern Art, New York: *Original art for "Book."*
　　　Galerie der Spiegel, Cologne, Germany: *Pastels, Boxes, Mirrored Room No. 3, and Cut-Paper Drawings.*
1970　The Pace Gallery, New York: *Chair Transformations.*
　　　Kunstverein Museum, Hannover, Germany: *Mirrored Room No. 3.*
1971　The Pace Gallery, New York: *Stiff Boxes and Autopolaroids.*
　　　Phyllis Kind Gallery, Chicago: *Acrylics, Pastels, Inks.*
　　　Museum of Contemporary Art, Chicago: *Box Retrospective.*
1972　The Pace Gallery, New York: *Chicken Wire Boxes.*
　　　Whitney Museum of American Art, New York: *Retrospective.*
1974　The Pace Gallery, New York: *Photo-Transformations.*
1975　Museum of Modern Art, New York: *Pastels.*
　　　Makler Gallery, Philadelphia.
　　　The Pace Gallery, New York, *"Samaras and Someothers," Cut-outs, Drawings and Boxes.*
　　　California State University, Long Beach, CA: *Photo-Transformations.*
1976　University of North Dakota Art Gallery, Grand Forks, ND: *Photo-Transformations.*
　　　Wright State University Art Gallery, Dayton, OH: *Photo-Transformations.*
　　　Institute of Contemporary Art, Boston: *Photo-Transformations.*
　　　Modern Art Pavilion, Seattle Art Museum, Seattle, WA: *Photo-Transformations.*
　　　A.C.A. Gallery, Alberta College of Art, Calgary, Canada: *Photo-Transformations.*
　　　The Pace Gallery, New York: *Phantasmata, Photo-Transformations.*
　　　Margo Leavin Gallery, Los Angeles: *Mixed Show.*
1977　Zabriskie Gallery, Paris: *Photo-Transformations.*
　　　Walker Art Center, Minneapolis: *Photo-Transformations.*
1978　The Pace Gallery, New York: *Reconstructions.*
　　　The Mayor Gallery, London.
　　　Akron Art Institute, Akron, OH: *Lucas Samaras: Fabric, Reconstructions & Photo-Transformation.*
　　　Jean & Karen Bernier, Athens, Greece.

1979　Richard Gray Gallery, Chicago: *Pastel and Bronzes*
　　　The Pace Gallery, New York: *Reconstructions*
1980　The Pace Gallery, Columbus, OH. *Reconstructions, Photo-Transformations.*
　　　The Pace Gallery, New York: *Photographs.*
　　　Margo Leavin Gallery, Los Angeles: *Reconstructions.*
1981　Galerie Watari, Tokyo: *Mixed Show.*
1982　The Pace Gallery, New York. *Pastels and Bronze Sculptures.*
　　　Denver Art Museum: *Samaras Pastels.*
　　　Richard Gray Gallery: *New Sculpture and Pastels.*
1983　Institute of Contemporary Art, Boston: *Pastels.*
　　　Jean and Karen Bernier, Athens, Greece: *Panoramas, Pastels.*
　　　Centre Georges Pompidou, Paris: *Photographs.*
1984　The Pace Gallery, New York: *Bronze Chairs and Faces.*
　　　Wildenstein, New York: *Pastels—A Retrospective.*
　　　Pace/MacGill Gallery, New York: *Panoramas.*
　　　International Center of Photography, New York: *Lucas Samaras: Polaroid Photographs 1969–1983.*
　　　Museum of Photographic Arts, San Diego, CA.
　　　Center for Photography, University of Arizona. Tucson, AZ
1985　The Pace Gallery, New York: *Recent Paintings.*
　　　Reed College, Vollum College Center Gallery, Portland, OR. *Polaroid Photographs. 1969–1983.*
1986　Pace/MacGill Gallery, New York: *Panoramas and Adjustments.*
　　　Jean and Karen Bernier, Athens, Greece: *Lucas Samaras.*
　　　The Pace Gallery, New York: *Lucas Samaras: Chairs and Drawings.*
　　　Phoenix Art Museum, Phoenix, AZ: *Lucas Samaras.*
　　　Serpentine Gallery, London: *Lucas Samaras.*

## SELECTED GROUP EXHIBITIONS

1959　Hansa Gallery, New York.
　　　Reuben Gallery, New York.
1960　Martha Jackson Gallery, New York: *New Forms, New Media.*
1961　Green Gallery, New York.
　　　Museum of Modern Art, New York: *The Art of Assemblage.*
1962　Dallas Museum of Contemporary Art.
　　　San Francisco Museum of Art: *The Art of Assemblage* (traveled from MOMA in New York).
　　　Green Gallery, New York.
　　　Museum of Modern Art, New York: *New Acquisitions.*
　　　Museum of Modern Art, New York: *Lettering By Hand.*
　　　Finch College Museum, New York: *American Figure Painting.*
1963　Green Gallery, New York.
　　　Corcoran Gallery, Washington, D.C.: *28th Biennial Exhibition.*
　　　Preston Gallery, New York: *Ten Man Show.*
　　　Washington Gallery of Modern Art; *Drawings.*
　　　Albright-Knox Gallery, Buffalo, NY: *Mixed Media and Pop Art.*

O.K. Harris Gallery, Provincetown, MA.
Dilexi Gallery, San Francisco.: 46 Works From New York.

1964    Rose Art Museum, Brandeis University, Waltham, MA: Recent
American Drawings.
Bianchini Gallery, New York.
Dwan Gallery, Los Angeles: Boxes.
Whitney Museum of American Art, New York: Sculpture Annual.

1965    Guggenheim Museum, New York: 11 From the Reuben Gallery.
Van Bovenkamp Gallery, New York: Contemporary Erotica.
Larry Aldrich Museum, Ridgefield, CT: The Richard Brown Baker Collection.
Whitney Museum of American Art, New York: Young America.
Sidney Janis Gallery, New York: Pop and Op.
New School Art Center, New York: Sculpture From The List Family Collection.
Rhode Island School of Design, Providence, RI: Contemporary Wall Sculpture and Boxes.
The Pace Gallery, New York: Beyond Realism.
Rhode Island School of Design, Museum of Art, Providence, RI: Recent Still Lifes.

1966    Whitney Museum of American Art, New York: Contemporary American Sculpture, Selection I.
Museum of Modern Art, New York: The Object Transformed.
Jewish Museum, New York: The Harry N. Abrams Collection.
Walker Art Center, Minneapolis, MN: Eight Sculptors: The Ambiguous Image.

1967    Larry Aldrich Museum, Ridgefield, CT: Highlights of the 1966–1967 Art Season.
University of Colorado, Denver, CO: L.A.-N.Y. Drawings of the 60's.
Los Angeles County Museum of Art, Los Angeles, CA: American Sculpture of the 60's. (Corridor #1).
University of St. Thomas, Houston, TX: Mixed Masters.
Art Institute of Chicago: Sculpture: A Generation of Innovation.
City Art Museum of St. Louis, St. Louis, MO: 7 for 67.
The 180 Beacon Collection of Contemporary Art, Boston, MA.

1968    Institute of Contemporary Art, London: The Obsessive Image.
Museum of Modern Art, New York: Dada, Surrealism, and Their Heritage.
Kassel, Germany: Documenta IV.
San Francisco Art Museum: Untitled.
Whitney Museum of American Art, New York: Sculpture Annual.

1969    Whitney Museum of American Art, New York: Human Concern/Personal Torment.
Fort Worth Art Center, Fort Worth, TX: Drawings.
Dallas Museum of Fine Arts, Dallas TX: One Mans' Choice.

1970    Sidney Janis Gallery, New York: String & Rope.
The Art Museum, Princeton University, Princeton, NJ: American Art Since 1960.
Foundation Maeght, St. Paul de Vence, France: Exhibition of Living

American Art.
Whitney Museum of American Art, New York: Sculpture Annual.

1971    Dublin, Ireland: Rosc 71.

1971–72    Munson-Williams-Proctor Institute Art Gallery, Utica, NY: Recent Painting and Sculpture.

1972    Kassel, West Germany: Documenta V.

1974    Whitney Museum of American Art, New York: The Twentieth Century: 35 American Artists.
The Art Institute of Chicago: 71st American Exhibition.
Newport, Rhode Island: Monumenta.

1975    Hayward Gallery, Arts Council of Great Britain, London, England.
Museum of Contemporary Art, Chicago: Bodyworks.
International Center of Photography, New York: Photo-Transformations (for Polaroid Corporation). Traveling exhibition.

1976    Whitney Museum of American Art, New York: Two Hundred Years of American Sculpture.

1977    Indiana University Art Museum, Bloomington, IN: Contemporary Color Photography.
Kassel, Germany: Documenta VI.
Museum of Contemporary Art, Chicago: A View of a Decade.
Sterling & Francine Clark Art Institute, Williamstown, MA: The Dada/Surrealist Heritage.

1978    Anderson Gallery, Virgina Commonwealth University, Richmond, VA: "Manipulative Photography."

1979    Institute of Contemporary Art, University of Pennsylvania, Philadelphia: The Decorative Impulse.
The New Gallery, Cleveland, OH: Photographic Surrealism.
Roanoke College, Roanoke, VA: East Side—West Side: New York Photography.
University of New Hampshire, Durham, NH: Self as Subject/A Direction in Contemporary Photography.
The Hunter Gallery, Hunter College, New York: Sculptors' Photos.
Venezia '79, photographic exhibition organized by Polaroid, Inc.

1980    Institute of Contemporary Art, University of Pennsylvania, Philadelphia: Drawings: The Pluralist Decade.
Brooklyn Museum, Brooklyn, NY: American Drawing in Black and White.
Venice Biennale, U.S. Pavilion: Drawings: The Pluralist Decade. Travels to museums in Spain, Portugal and Norway, June 1981.
University of California, Santa Barbara, CA: Invented Images.

1982    Thorpe Intermedia Gallery, Sparkhill, NY: Artist Photographers.
Palais des Beaux-Arts Brussels, Belgium Euralia: Art Grec Contemporain.
San Francisco Museum of Modern Art, San Francisco: Recent Color.

1983    Boise Gallery, Boise, ID: Arranged Image Photography.
Laguna Beach Museum, Laguna Beach, CA: Anxious Interiors.
Daniel Wolf Gallery, New York: Invention and Allegory.

1984    The Whitney Museum of American Art, New York: Blam: The Explosion of Pop, Minimalism and Performance 1958–1964.

Institute of Contemporary Art, University of Pennsylvania, Philadelphia: *Investigations.*
Jamaica Arts Center, Jamaica, NY: *Pieces Sewn.*
American Academy and Institute of Arts and Letters, New York: *36th Annual Purchase Exhibition.*

1985    Organization of Independent Artists, The City Gallery, New York: *Not Just Black and White.*
Baxter Art Gallery: California Institute of Technology, Pasadena, CA: *Painting as Landscape.*
University of Massachusetts, Fine Arts Center, Amherst, MA: *Offset: A Survey of Artists' Books.*
American Academy and Institute of Arts and Letters, New York: *37th Annual Purchase Exhibition.*
Solomon R. Guggenheim Museum, New York: *40 Years of Sculpture.*
Jeffrey Hoffeld & Co, New York: *Big Portraits.*
The Art Institute of Chicago: *75th American Exhibition.*

1986    The University of Alabama, Moody Gallery of Art, Tuscaloosa, AL: *Contemporary Work from the Pace Gallery.*
Summit Art Center, Summit, NJ: *VIEWPOINT, The Artist as Photographer.*
American Academy and Institute of Arts and Letters, New York: *38th Annual Purchase Exhibition.*

1987    Tampa Museum of Art, Tampa, FL: *Director's Choice.*
Arts Club of Chicago, Chicago: *Chairs as Art; Art as Chairs.*
Skidmore College, Saratoga Springs, NY: *Self-Portraits.*
Florida International University, Miami, FL: *American Art Today: The Portrait.*

1988    Walker Art Center, Minneapolis, MN: *Vanishing Presence.*

## SELECTED PUBLIC COLLECTIONS

Albright-Knox Art Gallery, Buffalo, NY.
Art Institute of Chicago, Chicago.
Australia National Gallery, Canberra, Australia.
City Art Museum of St. Louis, St. Louis, MO.
Dallas Museum of Fine Arts, Dallas, TX.
Denver Art Museum, Denver, CO.
Fogg Art Museum, Harvard University, Cambridge, MA.
Fort Worth Art Center, Fort Worth, TX.
General Services Administration, Fine Arts Collection, Hale Boggs Federal Courthouse, New Orleans, LA.
Solomon R. Guggenheim Museum, New York.
Hirshhorn Museum and Sculpture Garden, Washington, D.C.
Indiana University Art Museum, Bloomington, IN.
Los Angeles County Museum of Art, Los Angeles.
Metropolitan Museum of Art, New York.
Miami-Dade Community College, Miami, FL.
Museum of Art, Rhode Island School of Design, Providence, RI.
Museum of Contemporary Art, Chicago.
Museum of Modern Art, New York.
New Orleans Museum, New Orleans, LA.
Philadelphia Museum of Art, Philadelphia.
Phoenix Art Museum, Phoenix, AZ.
The Art Museum, Princeton University, Princeton, NJ.
San Francisco Museum of Art, San Francisco.
Seattle Art Museum, Seattle, WA.
Wadsworth Atheneum, Hartford, CT.
Walker Art Center, Minneapolis, MN.
Whitney Museum of American Art, New York.

# Bibliography

### Selected Books and Exhibition Catalogs

1961    Seitz, William C. *The Art of Assemblage*. New York: The Museum of Modern Art, 1961. Exhibition catalog.

1963    *Mixed Media and Pop Art*. Buffalo, NY: Albright-Knox Art Gallery, 1963. Exhibition catalog.

1964    *1964 Annual Exhibition of Contemporary American Sculpture*. New York: Whitney Museum of American Art, 1964. Exhibition catalog.

      *Recent American Drawings*. Introduction by Thomas H. Garver. Waltham, MA: The Poses Institute of Fine Arts, Brandeis University, 1964.

1965    *Eleven From the Reuben Gallery*. Edited by Alice Hildreth; text by Lawrence Alloway. New York: The Solomon R. Guggenheim Museum, 1965. Exhibition catalog.

      Mocsanyl, Paul. *Sculpture from the Albert A. List Family Collection*. New York: New School for Social Research, 1965.

      *Young America 1965, Thirty American Artists Under 35*. Foreword by Lloyd Goodrich. New York: Whitney Museum of American Art, 1965. Exhibition catalog.

1966    Baur, John I. H. *Contemporary American Sculpture: Selection I*. New York: The Howard and Jean Lipman Foundation and Whitney Museum of American Art, 1966. Exhibition catalog.

      Constantine, Mildred. *The Object Transformed*. New York: The Museum of Modern Art, 1966. Exhibition catalog.

      Friedman, Martin. *Eight Sculptors: The Ambiguous Image*. Minneapolis: Walker Art Center, 1966. Exhibition catalog.

      *Samaras: Selected Works 1960–1966*. Text by Lawrence Alloway. New York: The Pace Gallery, 1966. Exhibition catalog.

1967    Cunningham, C. C. *Sculpture: A Generation of Innovation*. Chicago: The Art Institute, 1967. Exhibition catalog.

      Friedman, Martina. *Recent Acquisitions, Volume 3*. St. Louis: St. Louis Art Museum, 1967. Exhibition catalog.

      ———. *Highlights of the 1966–1967 Art Season*. Ridgefield, CT: The Larry Aldrich Museum of Contemporary Art, 1967.

      Hunter, Sam. *The 180 Beacon Collection of Contemporary Art*. Boston: 180 Beacon Street, 1967.

      Matthews, George I. *A Point of View: Selected Paintings and Drawings from the Richard Brown Baker Collection*. Rochester, MI: Oakland University, The University Art Gallery, 1967. Exhibition catalog.

      Rickey, George. *Constructivism: Origins and Evolution*. New York: George Braziller, 1967.

1968    Arnason, H. H. *History of Modern Art*. New York: Harry N. Abrams, Inc., 1968.

1969    Doty, Robert. *Human Concern/Personal Torment*. New York: Whitney Museum of American Art, 1969. Exhibition catalog.

      Gercken, Gunther. *Documenta IV: Katalog, Vol. 2*. Kassel, W. Ger.: Druck & Verlag GamH, 1969.

      Goodman, Susan Tumarkin. *Superlimited: Books, Boxes and Things*. New York: The Jewish Museum, 1969. Exhibition catalog.

      Smith, Gordon M. *Contemporary Art—Acquisitions 1966–1969*. Buffalo,

      Tuchman, Maurice. *American Sculpture of the Sixties*. Los Angeles: Los Angeles County Museum of Art, 1967. Exhibition catalog. NY: Albright-Knox Art Gallery, 1969. Exhibition catalog.

1970    Ashton, Dore. *L'Art Vivant Aux Etas-Unis*. St. Paul de Vence, Fr.: Foundation Marguerite et Aime Maeght, 1970.

      Deamonstein, Barbarella. *Inside the New York Art World*. New York: Rizzoli International Publications, 1970.

      Samaras, Lucas. *Chair Transformations*. New York: The Pace Gallery, 1970. Exhibition catalog.

1971    *Highlights of the 1970–1971 Art Season*. Ridgefield, CT: Larry Aldrich Museum of Contemporary Art, 1971. Exhibition catalog.

      Samaras, Lucas. *Samaras Album*. New York: Whitney Museum of American Art and Pace Editions, 1971.

      Siegfried, Joan. *Lucas Samaras' Boxes*. Chicago: Museum of Contemporary Art, 1971. Exhibition catalog.

      Urrutia, Lawrence. *Continuing Surrealism*. La Jolla, CA: La Jolla Museum of Art, 1971. Exhibition catalog.

1972    Bunnel, Peter C. *Photographic Portraits*. Philadelphia: Moore College of Art, 1972. Exhibition catalog.

      Samaras, Lucas. *Lucas Samaras*. Edited with a foreword by Robert Doty. Text by Samaras. New York: Whitney Museum of American Art, 1972. Exhibition catalog.

1973    Hunter, Sam, and John Jacobs. *American Art of the Twentieth Century*. New York: Harry N. Abrams, Inc., 1973.

1974    Doty, Robert. *Photography in America*. New York: Whitney Museum of American Art, 1974. Exhibition catalog.

      Joachimides, C. M. *Eight Artists, Eight Attitudes, Eight Greeks: Stephen Antonakos, Vlassis Caniaris*. London: Institute of Contemporary Art, 1974. Exhibition catalog.

      Lieberman, William S. *Samaras 1974*. New York: The Museum of Modern Art, 1974. Exhibition catalog.

      Samaras, Lucas. *Photo-Transformations*. New York: The Pace Gallery, 1974. Exhibition catalog.

      ———. *Samaras and Someothers*. New York: The Pace Gallery, 1975. Exhibition catalog.

1975    Beaton, Cecil, and Gail Buckland. *The Magic Image*. Boston & Toronto: Little, Brown and Company, 1975.

      Glimcher, Arnold. *Lucas Samaras: Photo-Transformations*. Edited by Constance Glenn. New York: California State University, Long Beach and E. P. Dutton and Company, Inc., 1975. Exhibition catalog.

      Levin, Kim. *Lucas Samaras*. New York: Harry N. Abrams, Inc., 1975.

      Licht, Ira. *Bodyworks*. Chicago: Museum of Contemporary Art, 1975. Exhibition catalog.

      Savitt, Mark. *Richard Brown Baker Collects*. New Haven: Yale University Art Gallery, 1975. Exhibition catalog.

      *Sculpture of the 60s*. New York: Whitney Museum of American Art, 1975. Exhibition catalog.

      Tucker, William. *The Condition of Sculpture*. London: Hayward Gallery,

Arts Council of Great Britain, 1975.

1976  Haskell, Barbara. *Two Hundred Years of American Sculpture.* New York: Whitney Museum of American Art, 1976. Exhibition catalog.

McCabe, Cynthia. *The Golden Door: Artist-Immigrants of America, 1876–1976.* Washington, D.C.: Joseph H. Hirshhorn Museum and Sculpture Garden, Smithsonian Institution, 1976. Exhibition catalog.

Samaras, Lucas. *Phantasmata, Photo-Transformations.* New York: The Pace Gallery, 1976. Exhibition catalog.

Slivka, Rose. *The Object as Poet.* Washington. D.C.: Renwick Gallery, Smithsonian Institution, 1976. Exhibition catalog.

*Three Decades of American Art: Selections from the Whitney Museum of American Art.* Tokyo: The Seibu Museum of Art, 1976. Exhibition catalog.

Tucker, William. *A Selection of American Art: The Skowhegan School, 1946–1976.* Boston: Institute of Contemporary Art, 1976. Exhibition catalog.

1977  Coleman, A. D. *The Grotesque in Photography.* New York: A Ridge Press Book and Summit Books, 1977.

Delehanty, S. *Improbable Furniture.* Philadelphia: The Institute of Contemporary Art, University of Pennsylvania, 1977.

Hunter, Sam. *The Dada/Surrealist Heritage.* Williamstown, MA: Sterling and Francine Clark Art Institute, 1977. Exhibition catalog.

Pincus-Witten, Robert. *Postminimalism: American Art of the Decade.* New York: Out of London Press, 1977. Reprint of "Rosenquist and Samaras—The Obsessive Image and PostMinimalism."

1978  *Design and Art of Modern Chairs.* Osaka: The National Museum of Art, 1978.

Lipman, Jean, and Richard Marshall. *Art about Art.* Introduction by Leo Steinberg. New York: Whitney Museum of American Art, 1978. Exhibition catalog.

*Samaras: Reconstructions at the Pace Gallery.* Interview by Barbara Rose. New York: The Pace Gallery, 1978. Exhibition catalog.

Schiff, Gert. *Images of Horror and Fantasy.* New York: Harry N. Abrams, Inc., 1978.

Szarkowski, John. *Mirrors and Windows: American Photography Since 1960.* New York: The Museum of Modern Art, 1978. Exhibition catalog.

1979  Cummings, Paul. *Artists in Their Own Words.* New York: St. Martins Press, 1979.

Hall-Duncan, Nancy. *Photographic Surrealism.* Cleveland, OH: The New Gallery of Contemporary Art, 1979. Exhibition catalog.

Kardon, Janet. *The Decorative Impulse.* Philadelphia: The Institute of Contemporary Art, University of Pennsylvania, 1979. Exhibition catalog.

Levin, Kim. *Lucas Samaras: The New Reconstructions.* New York: The Pace Gallery, 1979. Exhibition catalog.

*One of a Kind: Recent Polaroid Color Photography.* Preface by Belinda Rathbone, curator; essay by Eugenia Parry Janis. Boston: David R. Godine, 1979.

Pirovano, Carlo. *Photography Venezia '79.* Milan: Gruppo Editoriale Eclecta S.P.A., 1979.

Sims, Patterson. *The Decade in Review: Selections from the 1970s.* New York:

Whitney Museum of American Art, 1979. Exhibition catalog.

1980  Bassett, Hilary D. *Painting and Sculpture Today/1980.* Indianapolis, IN: Indianapolis Museum of Art, 1980. Exhibition catalog.

Cortright, Steven. *Invented Images.* Santa Barbara, CA: University of California, 1980.

Leja, Michael. *Aspects of the 70's/Mavericks.* Waltham, MA: Rose Art Museum, Brandeis University, 1980. Exhibition catalog.

Ratcliff, Carter. *Lucas Samaras: Sittings 1979–1980.* New York: Pace Gallery Publications, 1980. Exhibition catalog.

Samaras, Lucas. *Crude Delights.* New York: Pace Gallery Publications, 1980.

1981  *Color.* Alexandria, VA: Time/Life Books, Inc., 1981.

*Five on Fabric.* Austin, TX: Laguna Gloria Art Museum, 1981. Exhibition catalog.

Hughes, Robert. *Shock of the New.* New York: Random House, 1981.

*Lucas Samaras.* Tokyo: Galerie Watari, 1981. Exhibition catalog.

*Lucas Samaras: The Pastels.* Foreword by Thomas P. Maythem; introduction by Dianne P. Vanderlip; essay by Peter Schjeldahl. Denver, CO: Denver Art Museum, 1981. Exhibition catalog.

1982  Ashton, Dore. *American Art Since 1945.* New York: Oxford University Press, 1982.

Elsen, Albert. *Casting/A Survey of Cast Metal Sculpture in the 80's.* San Francisco: Fuller Goldeen Gallery, 1982. Exhibition catalog.

Kuspit, Donald. *Samaras: Pastels and Bronzes.* New York: The Pace Gallery, 1982. Exhibition catalog.

Martinson, Dorothy. *Recent Color.* San Francisco: San Francisco Museum of Modern Art, 1982. Exhibition catalog.

Rose, Barbara. *Instant Fotografie.* Amsterdam: Stedelijk Museum Amsterdam, 1982. Exhibition catalog.

Schjeldahl, Peter. *Europalia: Art Grec Contemporain.* Brussels: Palais Des Beaux-Arts, 1982.

Schwartz, Sanford. *The Art Presence: Painters, Writers, Photographers, Sculptors.* New York: Horizon Press, 1982.

1983  Brown, Julia, and Bridget Johnson. *The First Show: Painting and Sculpture from Eight Collections 1940–1980.* Los Angeles: The Museum of Contemporary Art, 1983. Exhibition catalog.

Sayag, A., R. Marcel Mayou, P. Weiermair, and W. Ewing. *Lucas Samaras, Photos, Polaroid Photographs, 1969–1983.* Paris: International Center of Photography, Centre Georges Pompidou, 1983. Exhibition catalog.

Smagula, Howard. *Currents, Contemporary Directions in the Visual Arts.* Englewood Cliffs, NJ: Prentice Hall, Inc., 1983.

———. *Arranged Image Photography.* Boise, ID: Boise Gallery of Art, 1984. Exhibition catalog.

Weintraub, Linda. *Day in/Day out, Ordinary Life as a Source of Art.* Reading, PA: Freedman Gallery, Albright College, 1983.

———. *Sculpture Then and Now.* London: The Mayor Gallery, 1983.

1984  Blau, Douglas. *Samaras: Chairs, Heads, Panoramas.* New York: Pace Gallery Publications, 1984. Exhibition catalog.

Glimcher, Arnold. *Lucas Samaras Photo-Transformations.* New York: The Pace Gallery, 1984.

Green, Jonathan. *American Photography: A Critical History: 1945 to the Present.* New York: Harry N. Abrams, Inc., 1984.

Haskell, Barbara. *BLAM! The Explosion of Pop, Minimalism and Performance, 1958–1964.* New York: Whitney Museum of American Art, 1984. Exhibition catalog.

Kuspit, Donald B. *Artists Choose Artists III.* New York: CDS Gallery, 1984. Exhibition catalog.

Robins, Corinne. *The Pluralist Era, American Art 1968–1981.* New York: Harper & Row, 1984.

Schjeldahl, Peter. "Lucas Samaras." In *Art of Our Time, The Saatchi Collection,* Vol. 2. London: Lund Humphries London, 1984.

1985    *L'Autoportrait.* Lausanne, Switzerland: Musée Cantonal des Beaux-Arts, 1985. In French. Exhibition catalog.

Rogers-Lafferty, Sarah. *Body and Soul: Aspects of Recent Figurative Sculpture.* Cincinnati, OH: Contemporary Arts Center, 1985. Exhibition catalog.

Schjeldahl, Peter. *Paintings—Lucas Samaras.* New York: The Pace Gallery, 1985. Exhibition catalog.

1986    Baur, John I. H. *29 Sculptures from the Howard and Jean Lipman Collection.* Mountainville, NY: Storm King Art Center, 1986. Exhibition catalog.

Davvetas, Demosthenes. *Dialog/Dialogue.* Edited by Elizabeth Kaufmann. Baden-Baden, W. Germany: Kronen-Druck, 1986. In German and English.

Harthorn, Sandy. *Structured Vision: Collage and Sequential Photography.* Boise, ID: Boise Gallery of Art, 1986. Exhibition catalog.

*Individuals: A Selected History of Contemporary Art 1945–1986.* Introduction by Julia Brown Turrell. Los Angeles: Museum of Contemporary Art, 1986. Exhibition catalog.

Kuspit, Donald. *Lucas Samaras.* Athens: Jean Bernier Gallery, 1986.

## Selected Articles and Reviews

1960    Ashton, Dore. "Art Geometric Forms." *The New York Times* (February 12, 1960), p. 25.

1961    Hess, Thomas. "Collage as an Historical Method." *ARTnews* 60 (November 1961), pp. 30–33.

1962    O'Hara, Frank. "Art Chronicle." *Kulchur* 2 (Spring 1962), pp. 80–86.

1963    Rose, Barbara. "Dada Then and Now." *Art International* 7 (January 1963), pp. 22–28.

1964    Factor, Donald. "Boxes." *ARTFORUM.* (April 1964), pp. 20–23.

Rose, Barbara. "New York Letter: Lucas Samaras—His Life in Art." *Art International* 8 (November 1964), p. 54.

Tillim, Sydney. "Boxes." *Art in America* 52 (June 1964), pp. 98–102.

1966    Friedman, Martin. "The Obsessive Images of Lucas Samaras." *Art and Artists* 1 (November 1966), pp. 20–23.

Solomon, Alan. "Conversation with Lucas Samaras." *ARTFORUM* 5 (October 1966), pp. 39–44.

Waldman, Diane. "Samaras: Reliquaries for St. Sade." *ARTnews* (Ocotober 1966), pp. 44–46.

Willard, Charlotte. "Eye to I." *Art in America* 54 (March 1966), pp. 49–59.

1967    Samaras, Lucas. "An Exploratory Dissection of Seeing." *ARTFORUM* 6 (December 1967), pp. 26–27.

1968    Levin, Kim. "Views and Previews: Lucas Samaras." *ARTnews* 67 (December 1968), pp. 53–54.

Perreault, John. "Art: Cotton Scissors." *The Village Voice* (October 24, 1968), p. 17.

Samaras, Lucas. "A Reconstituted Diary: Greece 1967." *ARTFORUM* 7 (October 1968), pp. 54–57.

———. "Stealingman 1967." *Arts Magazine* 43 (September 1968), pp. 46–47.

1969    Levin, Kim. "Samaras Bound." *ARTnews* 67 (February 1969), pp. 35–37.

Willard, Charlotte. "Violence and Art." *Art in America* 57 (January 1969), pp. 36–43.

1970    Mellow, James R. "Cosy Objects Gone Berserk." *The New York Times* (October 25, 1970), p. D27.

Samaras, Lucas. "Autopolaroids." *Art in America* 58 (November 1970), pp. 66–83.

1971    Kurtz, Bruce. "Samaras' Autopolaroids." *Arts Magazine* 46 (December 1971), pp. 54–55.

1972    Glenn, Eugene. "Lucas Samaras by Kim Levin." *Print Collector's Newsletter* 3 (1972), pp. 168–169.

Kramer, Hilton. "Inspired Transformation." *The New York Times* (November 26, 1972), p. D17.

———. "Outrageous Invention in Samaras's Art." *The New York Times* (November 18, 1972), p. 33.

Levin, Kim. "Eros, Samaras and Recent Art." *Arts Magazine* 47 (December 1972), pp. 51–55.

Perreault, John. "Going the Way of All Flash." *The Village Voice* (November 30, 1972), pp. 34–35.

Pincus-Witten, Robert. "Rosenquist and Samaras: The Obsessive Image and Post-Minimalism." *ARTFORUM* 11 (September 1972), pp. 63–69.

Schwartz, Barbara. "An Interview with Lucas Samaras." *Craft Horizon* 32 (December 1972), p. 36.

1973    Kozloff, Max. "The Uncanny Portrait: Sander, Arbus, Samaras." *ARTFORUM* 11 (June 1973), pp. 58–66.

Samaras, Lucas. "Apropos du Film 'Self.'" *Opus International* 43 (April 1973), pp. 27–32.

Smith, Allison. "A Reflective Artist Takes a Peculiar Slant on the World." *Smithsonian* 3 (February 1973), pp. 72–77.

1975    Glueck, Grace. "To Samaras, the Medium is Multiplicity." *The New York Times* (November 24, 1975), p. 30.

Hoffeld, Jeffrey. "Lucas Samaras: The New Pastels." *Arts Magazine* 49

(March 1975), pp. 60–61.

Pluchart, F. "L'Art Corporel." *Artitudes International* 18 (January 1975), pp. 49–96.

Ries, Martin and Gregory Battock. "New York: Lucas Samaras' Powdered Absolute." *Art and Artists* 10 (June 1975), pp. 20–21.

Rose, Barbara. "Self-Portraiture: Theme with a Thousand Faces." *Art in America* 63 (January 1975), pp. 66–73.

1976    Gruen, John. "The Apocalyptic Disguises of Lucas Samaras." *ARTnews* 75 (April 1976), pp. 32–37.

Wortz, Melinda. "Revelations of the Self." *ARTnews* 75 (April 1976), pp. 36–37.

1977    Cardozo, Judith Lopes. "Reviews: Lucas Samaras." *ARTFORUM* 15 (March 1977), pp. 68–70.

Hugo, Victor. "Lucas Samaras, Art on Art." *Interview* (April 1977), p. 34.

Yamagishi, Shoji. "Photo-Transformations SX-70." *Camera Mainichi* (July 1977), pp. 66–68.

1978    Carr, Carolyn. "Lucas Samaras Photo-Transformations and Reconstructions." *Akron Art Institute* (December 1978), pp. 7–10.

Davis, Douglas. "Mirrors and Windows." *Newsweek* 92 (August 14, 1978), pp. 69–72.

Kramer, Hilton. "The New American Photography." *The New York Times Magazine* (July 23, 1978), pp. 8–13.

Meurie, Alan. "Lucas Samaras: Le Polaroid Narcissique." *Photo* (February 1978).

Rose, Barbara. "Lucas Samaras: The Self As Icon and Cultural Environment." *Arts Magazine* 52 (February 1978), pp. 144–149.

_____ . "Sewing His Life: Lucas Samaras." *Vogue* 16 (March 1978), pp. 246–247.

1979    Glueck, Grace. "The Piecework of Lucas Samaras." *The New York Times* (December 14, 1979), p. C21.

Levin, Kim. "The Word Drawings of Lucas Samaras: Thanatos and Post-Modernism." *Drawing* 1 (July 1979), pp. 25–28.

Mahon, Peggy. "Excerpts from Samaras Lecture." *Views* 1 (March 16, 1979), p. 3.

Muchnic, Suzanne. "From Flamboyant to Deliberate." *Los Angeles Times* (November 30, 1979), pp. 33–34.

Ratcliff, Carter. "Modernism Turned Inside Out: Lucas Samaras' Reconstructions." *Arts Magazine* 54 (November 1979), pp. 92–96.

Rickey, Carrie. "Art of Whole Cloth." *Art in America* 67 (November 1979), pp. 72–83.

1980    Galassi, Susan Grace. "Arts Reviews: The Photograph Transformed." *Arts Magazine* 54 (May 1980), pp. 28–30.

Kutzen, Peggy. "Artists by Artists: Lucas Samaras." *Arts Magazine* 54 (February 1980), p. 17.

Lifson, Ben. "Samaras's Nudist Colony." *The Village Voice* (December 17, 1980), p. 113.

1981    Kuspit, Donald B. "Exhibitionism." *Art in America* 69 (March 1981), pp. 88–90.

Levin, Kim. "Lucas Samaras." *Greek Accent* (July 1981), pp. 20–25.

Zelevansky, Lynn. "Lucas Samaras Sittings 8 x 10." *Flash Art* (March 1981).

1982    Bourdon, David. "A Conversation with Lucas Samaras." *Architectural Digest* (January 1982), p. 130.

Gifford, J. and Melvin B. Shestack. "A Man Who Won't Be Stereotyped." *American Photographer* (February 1982), pp. 80–83.

Levin, Kim. "Lucas Samaras." *Flash Art* (May 1982), p. 50.

Lifson, Ben. "Artists in Camera." *ARTnews* 81 (March 1982), pp. 102–3.

Samaras, Lucas. "Clay and Bronze." *ARTFORUM* 20 (March 1982), pp. 57–63.

Smith, Roberta. "Metamorphosis, by Lucas Samaras." *The Village Voice* (March 16, 1982), p. 84.

1983    Chevier, Jean-Francois. "Samaras: Les Court-Circuits Polaroids." *Beaux Arts* (October 1983), pp. 61–65.

Davvetas, Demosthenes. "Lucas Samaras." *Kimata* 10 (1983), pp. 15–19.

Moufarrege, Nicholas A. "Face to Face: Dust, Spit, and Thread: The Pastels of Lucas Samaras." *Arts Magazine* 57 (May 1983), pp. 74–77.

_____ . "Intoxication: April 9, 1983." *Arts Magazine* 57 (April 1983), pp. 70–76.

1984    Edwards, Owen. "The Uses of Enchantment." *American Photography* (October 1984), pp. 28–32.

Plagens, Peter. "Conversations with a Work of Art." *Aperture* (Fall 1984), pp. 50–59.

Ratcliff, Carter. "Art: Boxes of Mystery, Delighting the Senses with Unexpected Imagery." *Architectural Digest* 41 (August 1984), pp. 112–117.

Squires, Carol. "Photography—Lucas Samaras: Panoramas." *Vanity Fair* 47 (January 1984), pp. 15–20.

Stevens, Mark. "Paying Tribute to the 'Primitive.'" *Newsweek* 104 (October 1, 1984), pp. 92–94.

1985    Glimcher, Arnold. "Lucas Samaras." *Flash Art* (October 1985), pp. 40–44.

Samaras, Lucas. "The Marketplace." *ARTFORUM* 23 (Summer 1985), pp. 62–66.

Weiermair, P. "Lucas Samaras Polaroidfotografier 1969–83." *Louisiana Revy* 25 (July 1985), pp. 33–66. In Danish, summary in English.

Zelevansky, Lynn. "Lucas Samaras." *Photography Annual* (1985), pp. 62–67.

1986    Wise, Kelly. "Photographer's Pose: 'I give you myself . . .'" *The Boston Globe* (November 29, 1986), pp. 17–19.

1987    Heartney, Eleanor. "Lucas Samaras at Pace." *Art in America* (May 1987), p. 182.

Kuspit, Donald. "Lucas Samaras: The Pace Gallery." *ARTFORUM* (May 1987), p. 146.

Poirer, Maurice. "Lucas Samaras: Pace." *ARTnews* (May 1987), pp. 147–148.

Raynor, Vivien. "Art: Encrusted Chairs from Lucas Samaras." *The New York Times* (February 27, 1987), p. C23.